Drawing

THE HEAD AND FIGURE

Drawing
THE HEAD AND FIGURE

By JACK HAMM

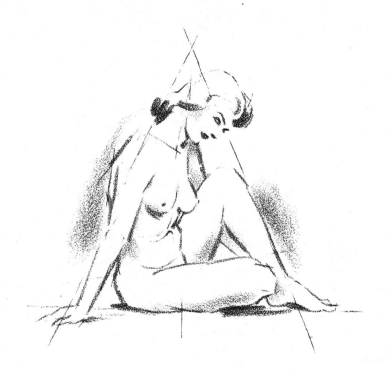

A PERIGEE BOOK

Dedicated to
My Wife, Dorisnel
Who Has Given Invaluable Assistance
All Along the Way

A Perigee Book
Published by The Berkley Publishing Group
A division of Penguin Putnam Inc.
375 Hudson Street
New York, New York 10014

First Perigee edition: January 1983
ISBN 0-399-50791-4

The Penguin Putnam Inc. World Wide Web site address is
http://www.penguinputnam.com

Printed in the United States of America
40 39

PREFACE

What in life is more important than people? Take people away and there's not much left. Take people out of art, and art becomes lonesome. Yet in art circles we hear, "He is good at almost everything — except his figure drawing." Indeed, if you can draw people well, you become a wanted individual in both commercial and fine art.

It is true that at some time or other everyone has tried to draw people. Long before a child learns to write, he makes marks which in his uninhibited imagination represent a person. No one has convinced him that he has no artistic ability, nor has he convinced himself, so he continues his unaffected effort to draw. Because he persists, oftentimes to the undoing of household furniture, walls — and parents — his drawings begin to show a decided measure of improvement. Then one day interest wanes, due to acquired restraints, and only a few after that regularly take up the drawing pencil. The others borrow the oft-repeated phrase, "Oh, I can't draw a straight line!" The plain truth is that, since we are not machines, no one can. An interesting crooked line is much more to be desired than one ruled along by a straight-edge, for it transcribes something of the person behind it, the pulse of life. Whereas an instrument like the compass or ruler may be used briefly as a device, it should always be subservient to the freehand line.

Now comes the great paradox. People are always watching people. How does it happen, then, that even among artists the way a person is put together remains an enigma? Of course, one reason is that the human body is not static like a rock or simple like an apple. Yet, because it is in such demand in art and is the dramatic focal point of our universal concern for life, we need to face up to it, learn it, record it, and profit from it.

When taken step by step and part by part, anatomy for the artist is not as inscrutable as one might suppose. In fact, like everything else, "it's simple when you know how." Then *knowing how* becomes the problem.

The purpose of this book is to approach the problem of figure drawing in such a way as to give the student something he can understand and remember. It goes without saying that nothing will ever take the place of practice, provided the practice is in the right direction and in earnest. The art student should strive to have endless patience and be doggedly persistent. If things don't go well in a given practice session, he should know that the best of art-

ists have had many such sessions. But, the remarkable thing about going through a disheartening session is that the student is very often on the threshold of marvelous discovery.

Carlyle said, "Every noble work is at first impossible." Many students, however, unwittingly prolong the travel time between the impossible and the possible. It is hoped that by the simplified approaches in this book the sincere student will see that good figure drawing is not impossible. The pencil, pen, or brush are not magic wands to be waved over the paper but are richly satisfying and rewarding instruments when perseveringly applied to a challenging piece of white paper.

JACK HAMM

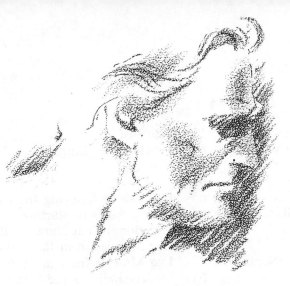

CONTENTS

CONTENTS

THE HEAD–IN SIX FREEHAND STEPS

1 Sketch the egg shape.

2 Divide it equally both ways. Mark off the horizontal line in fourths. Mark off the bottom half of the vertical line in fifths.

3 Place the eyeballs above the two top dots. Sketch the nose line on the 2nd dot down and the mouth line on the 2nd dot up.

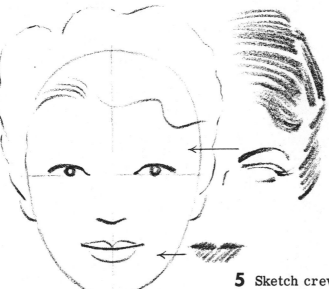

4 Sketch upper lid line and outer lip lines. Bottoms of ears come even with nose. Draw outline for hair.

5 Sketch crevice for top lid over eye and suggestion for lower lid. Add couple of lashes to top lid. Draw brow and bridge line of nose. Sketch in values for lips and hair.

6 Every face you do will look slightly different. Don't stop with one. Carefully draw a dozen or more until they begin to look right.

HEAD CONSTRUCTION — THE DOUBLE CIRCLE

A mechanical method of setting down the proportions of the ideal female head. This method is a learning device to acquaint the student with proportions. Use it sparingly — then sketch freehand!

1 Mark off line in fifths. This represents width of head which is approximately five eyes wide. Later, eyes will come below 2 and 4.

2 Place compass point in center of 3 at dot A. Draw circle crossing point B, enclosing line which is five eyes in length.

3 Draw vertical line through center A. Add distances 6 and 7 same as eye units 1 through 5. C will be tip of nose later.

4 Divide distance 6 in half, finding point F. Use this point for center of smaller circle reaching to E which becomes bottom of chin. F will be top of mouth and D bottom of mouth.

5 Carefully join each circle with lines G and H. Be sure that lines do not go inside or outside of circles.

6 Draw line J to K at exact point where lines G and H touch large circle. Top of eyes will later touch line J-K.

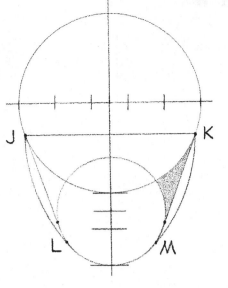
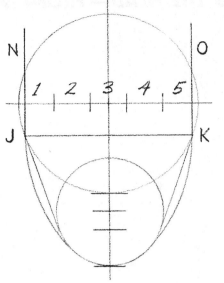
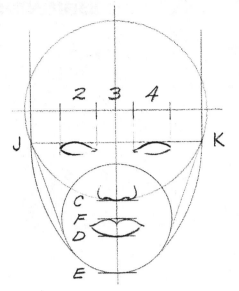

7 Use point J to subscribe arc K-M. Likewise use Point K to subscribe arc J-L. These arcs will become cheek lines. Shaded area is indention below cheek bone which may or may not show on finished face.

8 Draw two vertical lines from points J and K. These lines N-J and O-K will be sides of head. Notice how they trim off sides of large circle slightly.

9 Draw eyes below line J-K directly below numbers 2 and 4 of the original starting line. Draw nose on line C directly below number 3 of original starting line. Draw mouth between lines F and D. Make mouth overall a little wider than nose.

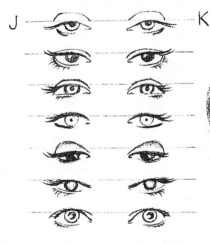

Eyelids may be full or shallow and will come just above line J-K. Upper lid may not show at all. Eyes may be dark, light or in between. Various shapes and slants of eyes may be tried.

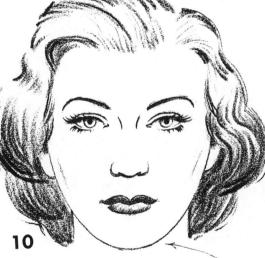

10

Cheeks may be flatter and chin may vary in shape.

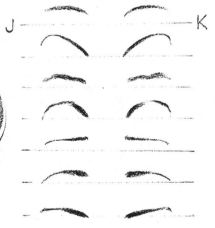

Draw brows halfway between eyes and original starting line. Achieve variety here. Notice brow possibilities.

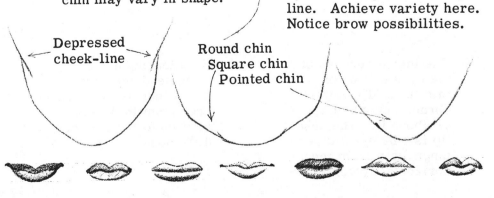

Depressed cheek-line

Round chin
Square chin
Pointed chin

The straight mouth has many variations.

BEGINNING THE HEAD—FRONT VIEW

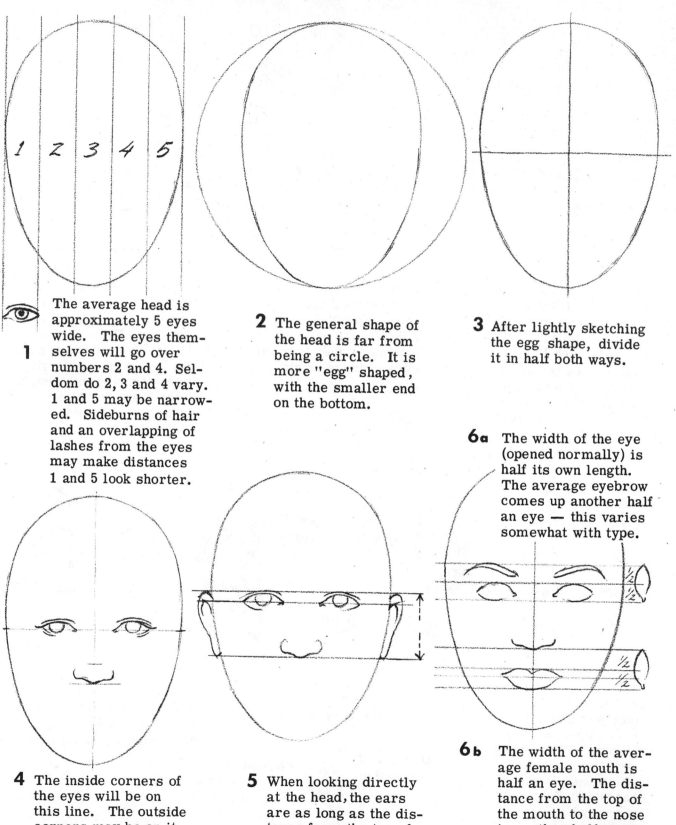

1 The average head is approximately 5 eyes wide. The eyes themselves will go over numbers 2 and 4. Seldom do 2, 3 and 4 vary. 1 and 5 may be narrowed. Sideburns of hair and an overlapping of lashes from the eyes may make distances 1 and 5 look shorter.

2 The general shape of the head is far from being a circle. It is more "egg" shaped, with the smaller end on the bottom.

3 After lightly sketching the egg shape, divide it in half both ways.

6a The width of the eye (opened normally) is half its own length. The average eyebrow comes up another half an eye — this varies somewhat with type.

4 The inside corners of the eyes will be on this line. The outside corners may be on it or above it. The nose tip is 1 1/2 eyes' distance away from the horizontal center line.

5 When looking directly at the head, the ears are as long as the distance from the top of the eyes to the bottom of the nose.

6b The width of the average female mouth is half an eye. The distance from the top of the mouth to the nose is another half an eye. The width of the top lip is usually about 1/3 the depth of the mouth.

7 Many students are not able to construct a well-proportioned face because they violate the equilateral law of facial feature arrangement. Individual features may be well drawn, but if they are not in the right place the whole countenance will look wrong.

Looking directly at the face, distances A, B and C should be the same. Be sure to exclude the eyelashes. (There are some attractive faces that are the exceptions, but this is the rule.)

Common failings are: Eyes that are too close together, noses that are too long or short, mouths that are too far removed from the eyes, chins that are too big, etc. Simply the knowledge of this triangle safeguard will assist in placing features correctly.

8 As stated in the first paragraph, the average head is 5 eyes wide. There may be some variance where the dotted lines appear. From the top outside of the nostril to the eye is one eye's distance. The nose itself is one eye in width.

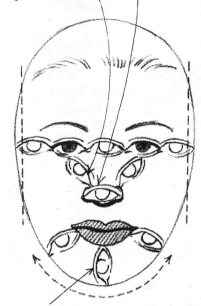

This eye's distance may be rotated around the outside of the bottom lip, thus finding the chin and lower cheek line.

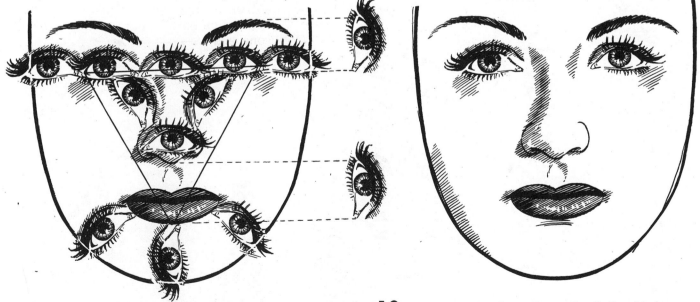

9 Here is a sinister diagram with the eye unit actually placed in the locations talked about.

10 Above is the face "wearing" the features as we are accustomed to seeing them.

5

EXPERIMENTING WITH A FLATTENED PENCIL

In all the arts requiring the drawing of people, preliminary sketches are of great value. In developing these "roughs" make very light foundational lines first.

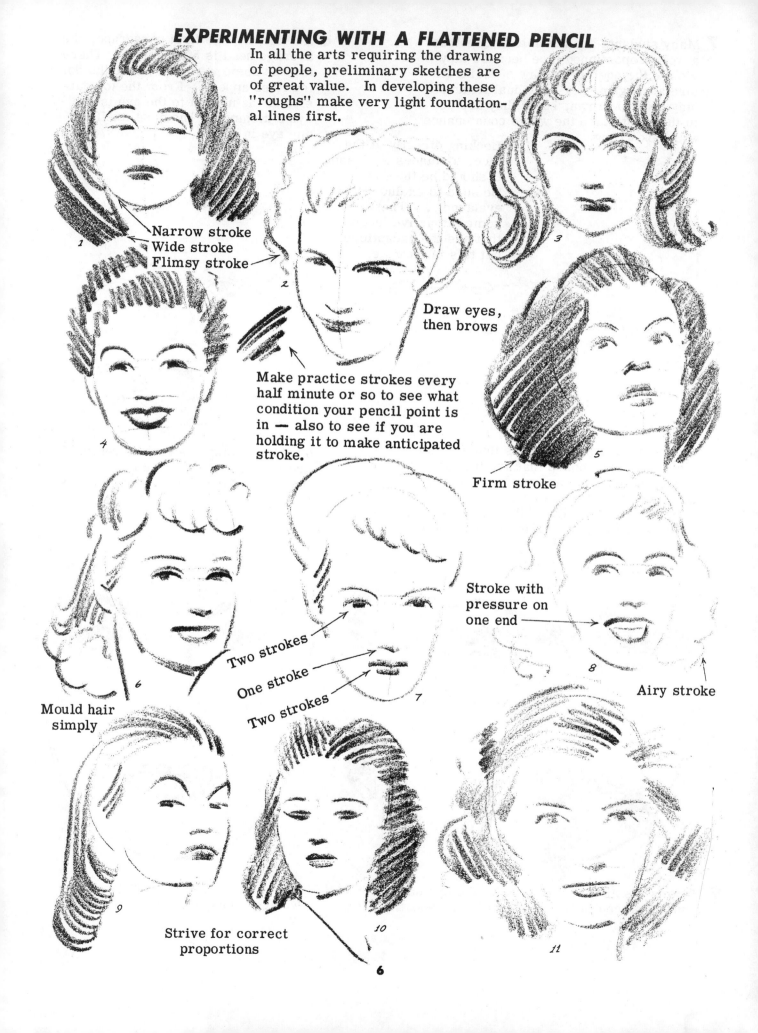

Narrow stroke
Wide stroke
Flimsy stroke

Draw eyes, then brows

Make practice strokes every half minute or so to see what condition your pencil point is in — also to see if you are holding it to make anticipated stroke.

Firm stroke

Stroke with pressure on one end

Two strokes
One stroke
Two strokes

Airy stroke

Mould hair simply

Strive for correct proportions

THE EYE— STEP BY STEP

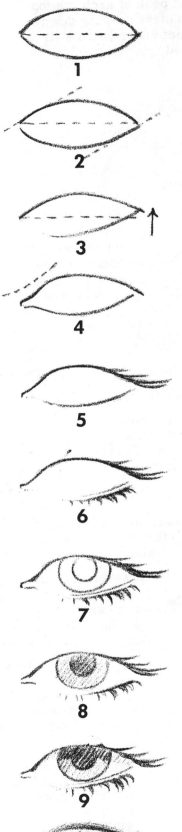

Here is a suggested way of "building" the female eye.
Note: Always sketch lightly at the beginning. This will leave
your work pliable and manageable. The diagrams at
the left are more heavily drawn for emphasis.
The basic shape of the human eye is the football ellipse.

Choosing the point on the left side as the inside corner, this
basic shape may be slightly flattened at top left and bottom right.

The outer or right corner may be lifted a little above the
original center line (optional).

The inner area at top left often is bowed in (again optional).

Now, upon this foundation add several sweeping lashes at
top right.

Sketch in shorter lashes in abbreviated clusters at bottom right.
Add a light second line parallel to this lash line. This defines
the thickness of the lower lid. Begin to minimize lower left
outline. This is the fade-away portion which will keep eye from
looking too hard and unnatural.

Decide on direction of gaze and put in outer iris edge with inner
pupil outline. Make slight wedge-like emphasis by inside corner.

Sketch dark and light values in the circles. Gradation of values
varies with selected color of eye.

Add shadow area over iris on either side of pupil. A lighter
shadow area (beneath top lid) may be laid over "white" portion
of eye — on smaller drawings this may be omitted.

Add top fold of eyelid. This may be a narrow or wide strip or
it may hardly show at all. Heavy up the line out of which grow
the top eyelashes — this may be done all the way across. Put
in highlight either with opaque white or eraser.

POINTERS IN DRAWING THE EYE

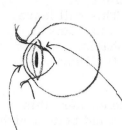

In the eyebrow, hairs grow obliquely away from nose.

At the peak of arch the top hairs start growing down to meet under hairs still slanted up.

The cornea is like a mound on the eyeball. The slight depression where one merges into the other may pick up a little more shadow. This helps to give eye feeling of dimension.

Bright light stimulates circular fibers in iris and constricts pupil. In darkness pupil gets larger.

Margin of upper lid rounds off here. Margin of lower lid squares off here and usually shows, especially from midway to outside corner.

Notice how lower lid pocket is moulded around eyeball.

Fleck of white at lowest point of lower lid curve indicates excess moisture in eye. This will appear more pronounced in sad, crying eye.

In looking at a near object the pupil is small; in looking at a distant object it is large. (If in bright sunlight, the lids will squint to accommodate.)

Top lashes curl up and lower lashes curl down so they do not interlace when eye is closed.

However, lashes with pronounced curl come down before they swoop up. Hence the scallop that often appears here.

As lid lowers, sharp fold may become depression in shadow.

The lower the lid the deeper the shadow over the iris.

Same applies in reverse (though not as much) to lower lashes.

Highlight is caught by clear, wet surface of cornea's transparent tissue. In a room with multiple lights two or three highlights may appear.

Lashes are actually arranged in double or triple rows at the margin of lid. This gives them tendency to cluster as they come out.

8

Sparkle or liveliness is obtained by drawing pupil in its entirety. Avoid showing shadow from lid or lashes on iris or pupil (for maximum sparkle).

More sparkle can be obtained by placing highlight spot high on the eye.

Here is a "wet" highlight and beside it a "contour" highlight.

Sometimes it is quite effective to show a dash of highlight across portion of iris and pupil.

There actually is a break in the corner where lashes do not appear. It is a mistake to draw them all around the eye.

However, shadow from the extended lashes may fall on the skin beside the eye. Even in a small drawing this may be subtly shown, though it is not necessary.

Whenever mouth is in laughing position, the lower lid pushes up, covering part of iris.

The iris (meaning "rainbow") is the colored portion of the eye. The markings of coloration converge toward the pupil. The various shades of blue eyes are caused by pigmentation of the lens capsule showing through the texture of the iris. Gray, brown and black eyes get their coloration from pigment granules in the iris itself. Other colors of eyes are mixtures of these with the blue (which is always there in all eyes) and the influence of the tiny channels of arteries, veins and nerves. This coloration is more in evidence at the outer edges of the iris.

Some eyelids have several delicate skin folds which may become more pronounced with age.

The natural color of the lids may be somewhat darker than surrounding flesh.

As the eye is opened, most of the upper lid is withdrawn in a deep fold here.

An eye focused downward will appear elliptical. The eyeball starts to turn under as it points its lens at its intended subject.

The margin of the lower lid is really thinner than that of the upper lid. It shows more because it is moist and slick and catches light readily.

THE EYE WHEEL

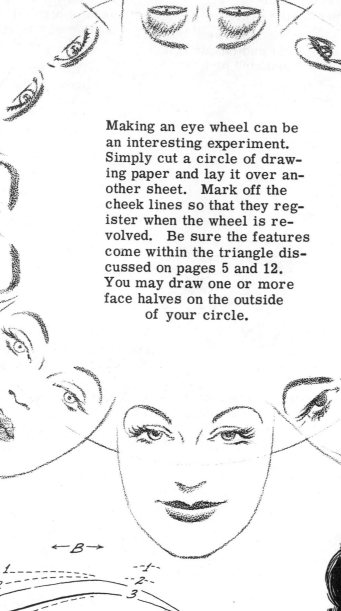

Making an eye wheel can be an interesting experiment. Simply cut a circle of drawing paper and lay it over another sheet. Mark off the cheek lines so that they register when the wheel is revolved. Be sure the features come within the triangle discussed on pages 5 and 12. You may draw one or more face halves on the outside of your circle.

One reason why there are millions of different-looking people in the world is because of the endless combinations of features — yet they all take place within a few square inches of "face space." With everyone being limited to just two eyes, one nose and a mouth, you would think most humans would look like everybody else. For the most part the contrary is true. We are a world of individuals with as many separate countenances. Even so, the artist finds himself getting into a rut when it comes to types of faces. To offset this he should file mentally scores of feature differences. The rewards are great!

The eye is the number one feature transmitting thoughts behind expressions. There are eight areas of exterior response which may work singularly or in combination: the three general areas of skin alteration (where lines may appear) A, B & C; and five sets of horizontals which may move up and down, twist and tilt — these are represented by the five columns of numbers in the above diagram. Though the normal setting of the eye and brow differs with people, number 3 above in each column is considered the normal awake setting. Try flexing the muscles around your eyes before a mirror. Learn what can be done in these tell-tale response areas.

10

PORTRAYING THE FEMALE MOUTH

The mouth is singularly the most important feature of the face for conveying the mood or feeling of the individual. It is the number one sign of expression. It is forthright and seldom subtle as the eyes may be. The corners of the mouth alone speak worlds.

There are around 24 skin creases across the length of each lip. In pronouncing sounds like "o" and "u" they show up more. In a laugh they nearly disappear. They run off the mouth into the face as old age comes on. Even on painted lips a highlight may be divided because of these creases.

Protrusion
Indention

Hollow above mouth
Part known as "Cupid's bow"

Corner depression which may register interesting shadow.

Upper lip rim may project farther than lower lip.

If dotted line following curve of bottom lip were extended it would cut back into face. Dotted line of top lip would shoot off into space. This is the general rule along the full part of the female mouth.

Depression may occur here.

Darkest part of the mouth is the line of the aperture itself.

Under lip may catch shadow from projected upper lip.

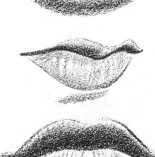
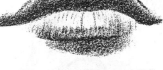
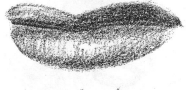
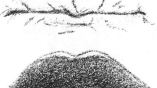

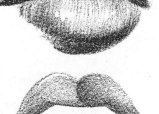
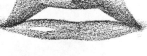
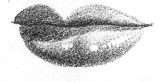
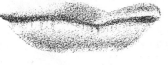
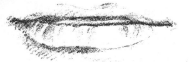

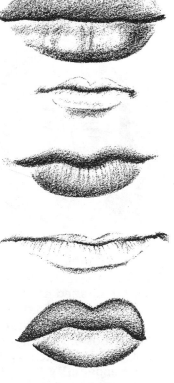
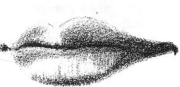

11

THE LAUGH AND THE TRIANGLE

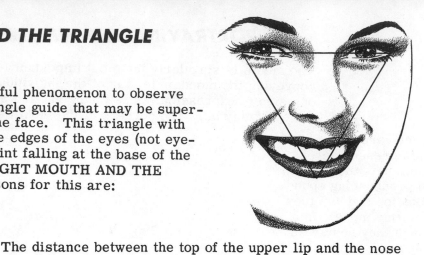

Here is an interesting and helpful phenomenon to observe concerning the equilateral triangle guide that may be super-imposed over the features of the face. This triangle with the two top points at the outside edges of the eyes (not eye-lashes) will have the bottom point falling at the base of the lower lip IN BOTH THE STRAIGHT MOUTH AND THE LAUGHING MOUTH. The reasons for this are:

1 The distance between the top of the upper lip and the nose is lessened (by the stretch from side to side). Ordinarily this distance is half an eye (the unit of facial measurement).

2 Even though the lips are parted and the distance B is increased, the distance A is shortened. Hence, A and B together still add up to the one eye unit length.

3 The distance from the bottom of the lower lip to the nose is approximately the same in the LAUGHING MOUTH and the STRAIGHT MOUTH. In a normal laugh the set of the teeth and the position of the chin are nearly the same as when the lips are in a straight placement.

4 The foregoing is true in the NORMAL laugh. It is not so with the yelling laugh or the hilarious laugh when the jaw is forced open. Nor is it true when the mouth flies open in awe or wonderment.

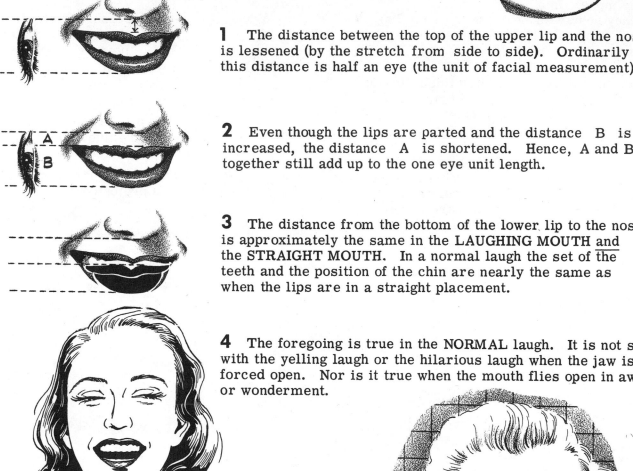

The above mouth is open abnormally. Despite this fact, the investigator will often be amazed at the results of the triangle check. Just because you wish to draw a wide-open mouth, don't extend the bottom triangle point too far. The lips on the face at the right are full -- especially for a hearty laugh -- yet the three points of the equilateral triangle fall into place remarkably well. Try the measurements and see for yourself.

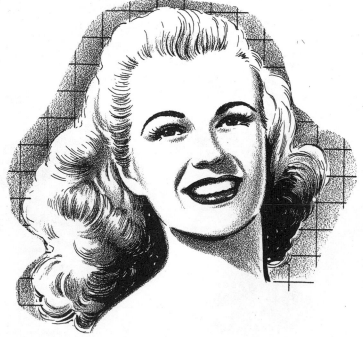

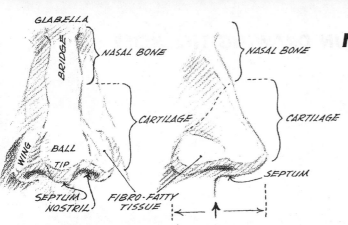

GLABELLA
BRIDGE
NASAL BONE
NASAL BONE
CARTILAGE
CARTILAGE
WING
BALL
TIP
SEPTUM
SEPTUM NOSTRIL
FIBRO-FATTY TISSUE

In the above diagram the various external parts of the nose are identified. Notice that the nasal bone comes down almost halfway before the cartilage takes over. This is sometimes marked by a slight widening. The glabella is the smooth area between the brows. The profile nose is half on the face and half off (see middle-point arrow).

NOSE CONSTRUCTION

In the column at the right are the lower areas of noses which might be either male or female. The greater difference between the two is told by the front view where the male characteristics are less delicate. Find and name the nose parts in the semi-front view sketched below.

1 Pointed tip, flat septum.

2 Septum tapered into tip.

3 Exposed nostril, angled wing.

4 Pert nose, small nostril.

MALE NOSES

1 Aquiline tip, hooked around end.

2 Relatively flat plane across nostrils.

3 Large round ball, nostrils hidden.

4 Small round ball, nostrils barely discernible.

5 Wide ball, tapered septum.

6 Small ball squared.

FEMALE NOSES

1 Septum drawn into nostril.

2 Large straight-across nostrils.

3 Rounded nose parts, small nostrils.

4 Low-hanging septum, large nostrils.

5 Flat septum, squared wings.

6 Shape some consider standard.

5 Nostril angled down.

6 Long nostril, rolled septum.

7 Angled septum.

8 Under part flat.

9 Back of wing flattened.

USING THE FEWEST LINES IN DRAWING THE NOSE

Above are eight simple suggestions for front view female noses. It is usually well to indicate the two depressions on either side of the nose between the eyes — at least put in one of them. The nostril cavities may be lost in the thin shadow of fig. 2 (line may be thickened denoting a little more shadow) — this is the simplest way of treating the nose. Never put in two round holes by themselves. The two slash marks of fig. 1 may be used without the outside nostril lines but should be carefully placed. A line along the side of the female nose is always risky for the beginner and might best be left out. In 3, 4, 7, and 8 a feeling of light is coming from top right. The nose will take a little shadow without any being placed elsewhere on the face proper. A corresponding bit may be added beneath the chin, however.

Here are eight ways of drawing the male nose in a semi-front position. The patterns for both male and female may be interchanged. The male is usually more coarse; the female more delicate. The farthest nostril "wing" may or may not be in evidence, depending on the relative width and length of the lower part of the nose. The wider the nose between the outer nostrils, the more likely the farthest one will show. As the face is turned toward you both wings will show in any event.

Below are a dozen nose variations, the completed profile with the first.

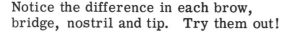

Notice the difference in each brow, bridge, nostril and tip. Try them out!

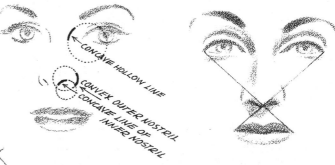

Above, a reminder of the simple arcs (black lines) that may be used. Don't draw the circles.

If lines are drawn from eye corners to lip corners, the crossing point will be close to the nose tip. (For a straight head-on view only.)

Study similarity of nose and cheek shadows at left. These two treatments worth their weight in gold!

How much attention to give the vertical alongside the front-view nose? If entire face is in partial shadow, it can't be ignored. If face is in full light, be safe, treat it lightly.

THE NOSE FROM VARIOUS ANGLES

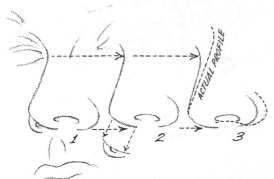

1 A semi-front nose.
2 The far nostril re-moved and brought down (look at its shape).
3 The same nose in flat profile (dotted). Notice how the bridge line changes going back to the tilted semi-front view.

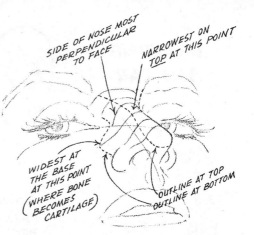

SIDE OF NOSE MOST PERPENDICULAR TO FACE

NARROWEST ON TOP AT THIS POINT

WIDEST AT THE BASE AT THIS POINT (WHERE BONE BECOMES CARTILAGE)

OUTLINE AT TOP
OUTLINE AT BOTTOM

Above examine the various cross-sections of the fore-shortened nose. See how the base attaches to the face.

1 A nose turned so that the far nostril cavity is just out of sight.
2 Only the wing's rim is showing.
3 Observe how the far cavity hugs the septum line, being just beyond it. Here the far nostril cav-ity is but a trace. Same drawing in line below.

The far eye sets like the sun beyond nose's ridge.

SKULL CAVITIES

CARTILAGE AREA

BONE (UPPER MAXILLA OF SKULL) WHICH MAKES BASE OF NOSE SWELL SLIGHTLY HERE

In the diagram at the right the skull's opening is pictured behind the nose. Acquaint yourself with the mound of bone on either side of the cavity. Feel of your own. This will sometimes catch a highlight; it is a gentle rise be-tween the sink of the inside eye corner and the sink beside the nostril wing.

Wide furrowed septum squared onto area above lip.

Under view show-ing angle of wing attachment, very narrow septum.

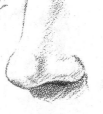

Top view, wings extra wide apart, rounded ball.

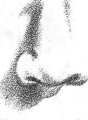

Squared ball, flattened under surface, low flat wing.

High, rounded wings, thick undefined ball.

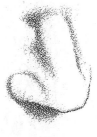

Wing groove brought for-ward and down, tip flattened.

DRAWING THE EAR

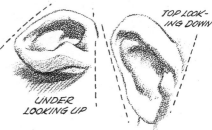

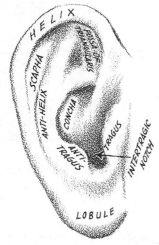

SIMPLIFYING THE EAR IN SIX STEPS

Above are the major parts of the ear set down in a suggested sequence. The basic construction of all ears is the same even though they may differ somewhat in appearance. Notice how the lines in fig. 2 bypass each other. The "Y" in fig. 3 is raised; the area immediately surrounding is lowered. In fig. a at the far right observe how the helix or rim at the top may go behind itself. Too, see how in fig. b the rear rim may bow toward the head, or in G (next to the bottom line-up) it may bow away from the head. In figs. a & c the anti-helix or tail of the "Y" (marked x) may protrude in some instances.

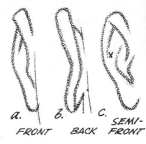

Though it is not necessary to learn the names of the parts, for your information they are given above left. The tragus and anti-tragus are designed to protect the notch or orifice between, into which the sound enters the head. The concha is the deepest part of the outer ear structure and nearly always catches some shadow. The lobule is softer and less rigid than the rest of the ear. It may grow out from the head or hang pendant-like from the ear.

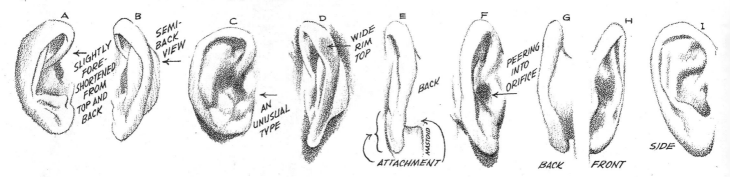

Above are different ears from various angles. Looking down from the top and back (A) the forward part of the helix appears to loop in sharply above the orifice (hole). The front of the lobe is attached just above the articulating part of the lower jaw (feel yours with your finger), and the back of the concha attaches just in front of the mastoid bone (see drawing E).

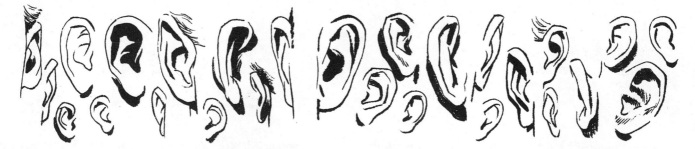

Examples of ears done with pen or brush using ink. Different lighting playing on the many ridges produces numerous possibilities. Learn the essentials of the ear's form, and observe ears!

THE NATURAL FALL OF HAIR

As VARIETY is the keynote in much of art, so variety plays a great part in every well-drawn coiffure. In the magnified section of hair in the circle at the bottom of the page notice the variety of widths in the swirling locks of hair. The next time you are sitting behind a woman observe the layers of locks. In the diagram the under-locks 1, 2 and 3 are of varying widths. The same is true with the over-locks 4, 5 and 6. Yet each set of locks combines to form a tuft-unit owing to common value (darkness or lightness which may be due to shadow) or common swirl (the direction of the separate tresses).

1 Even though hair has been run through a comb and is hanging naturally, it has a tendency to spring into individual clusters. One reason for this is that the scalp is not level. The follicles holding the hair roots are slanted differently on this changing scalp line. Consequently the hair soon forms a lock after it leaves the surface of the scalp.

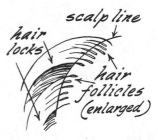

scalp line
hair locks
hair follicles (enlarged)

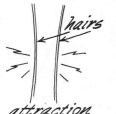

hairs
attraction

2 A second reason for these clusters is that the hair picks up electricity and each hair is attracted to the next hair. So they arrange themselves in groups as they hang.

3 The head moves more (under most circumstances) than any other external part of the body. This, along with subsequent shifting of air currents about the head, causes light-textured hair to break up into mobile strands and tufts.

The degree of dryness or oiliness as well as the weight of the hair itself has much to do with the way hair falls.

4

5 Artificial devices and setting solutions may divert the natural fall of the hair. Even so, it must be made to resemble the pliable, airy material it really is.

A CLOSE-UP OF HAIR

In the inner circle on the right you have the minor breakdowns of locks of hair as they might appear. Of course, with a toss of the head this formation would change.

The arrows at the bottom indicate the general direction all the hair is going. A and B locks finally fall into line perhaps to separate a little farther down.

Study the various widths of all the hair strands 1 through 10. Natural variety is one of the keynotes in successfully drawing hair.

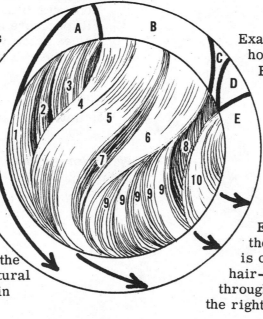

Examine the locks. Notice how strands 4 and 5 in lock B are separated by a depression no wider than a line; whereas, strands 5 and 6 have a deeper and wider depression 7. See how strand 6 turns completely over into the sub-strands marked 9's. Eight is a deeper depression than 7 and darker. Eight and 10 are going in the same direction, but 10 is on top of 8. The general hair-set of all the locks A through E is influenced toward the right at the bottom.

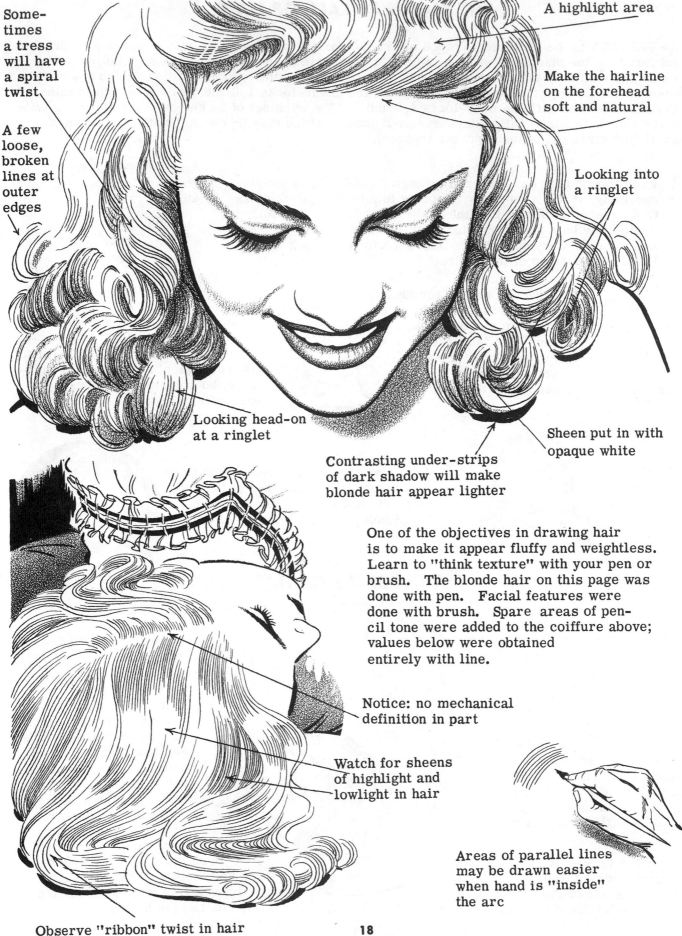

Sometimes a tress will have a spiral twist

A few loose, broken lines at outer edges

A highlight area

Make the hairline on the forehead soft and natural

Looking into a ringlet

Looking head-on at a ringlet

Sheen put in with opaque white

Contrasting under-strips of dark shadow will make blonde hair appear lighter

One of the objectives in drawing hair is to make it appear fluffy and weightless. Learn to "think texture" with your pen or brush. The blonde hair on this page was done with pen. Facial features were done with brush. Spare areas of pencil tone were added to the coiffure above; values below were obtained entirely with line.

Notice: no mechanical definition in part

Watch for sheens of highlight and lowlight in hair

Areas of parallel lines may be drawn easier when hand is "inside" the arc

Observe "ribbon" twist in hair

18

SUGGESTED SIMPLIFICATION OF HAIR

This drawing is presented for the purpose of studying further what hair actually does. Before one can interpret, simplify or abstractly portray hair, he should become familiar with the real thing.

Using the above sketch style, partially outline the changes of plane (where the whites become grays and the grays become blacks) in the hair on the big head. Try treating the sections as a mass.

A.
LIGHT
BRUNETTE
(OR RED)

B.
BLONDE

C.
DARK
BRUNETTE
(BLACK)

At left are two excerpts of hair done in a still freer style than that on the large head. The blonde is pen. The black is brush. In the freer blonde technique, leave out more lines than example B. In the more casual black rendering, add to, in fact, close up the bulk of the numerous lines in example C so that you are working with wider blacks. Strive to become inventive in your own style.

WAYS OF DRAWING DARK HAIR

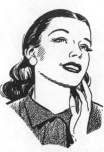

There may be times when you will portray black hair by making it completely solid, but it is likely to look flat. Bits of sheen and sparkling whites will give it life and lustre. In the midst of a sea of black make the small line groups go with the flow of hair.

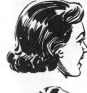

When there is a crisp demarcation between black and a strip or spot of highlight, it is best to put in the blacks first (A). If there is a merging of black into the highlight, start with your line group and close it into black by pen or brush pressure (B).

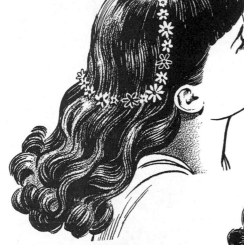

Above is an example of a pencil screen thrown over the lighter areas after the darks have been applied. Use a grained 2-ply board.

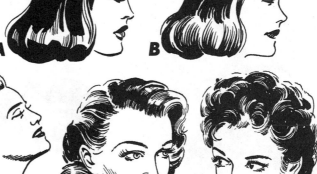

In every coil or round mound of hair there are at least a few lines that run clear through the highlight. Try limited flecks of opaque white also.

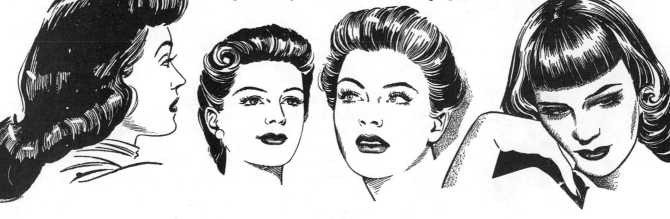

WAYS OF DRAWING LIGHT HAIR

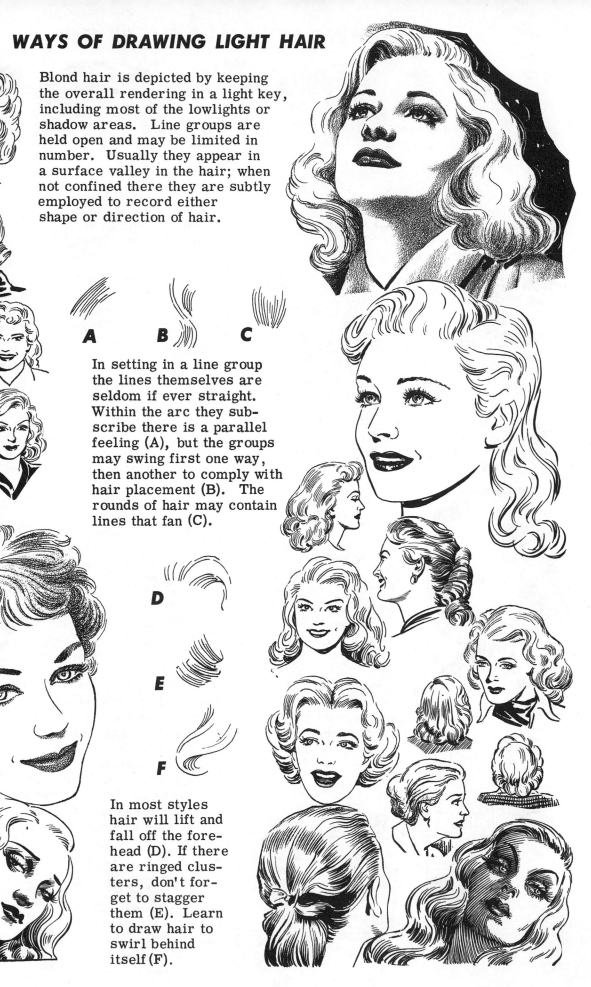

Blond hair is depicted by keeping the overall rendering in a light key, including most of the lowlights or shadow areas. Line groups are held open and may be limited in number. Usually they appear in a surface valley in the hair; when not confined there they are subtly employed to record either shape or direction of hair.

A B C

In setting in a line group the lines themselves are seldom if ever straight. Within the arc they subscribe there is a parallel feeling (A), but the groups may swing first one way, then another to comply with hair placement (B). The rounds of hair may contain lines that fan (C).

D

E

F

In most styles hair will lift and fall off the forehead (D). If there are ringed clusters, don't forget to stagger them (E). Learn to draw hair to swirl behind itself (F).

DRAWING MEN'S HAIR STEP BY STEP

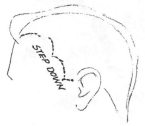 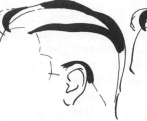 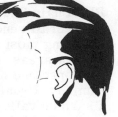 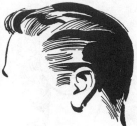

1 Pencil skull and ear line.

2 Decide on hair line and amount of hair rise.

3 Brush line just below part, behind ear, top and front.

4 Fill in rest of darks suggesting highlights.

5 With pen put in middle tones in fleecy groups.

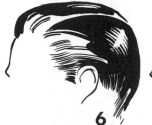 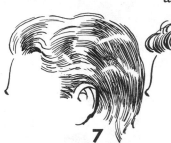 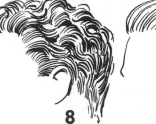 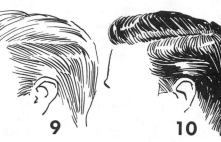

6 **7** **8** **9** **10**

Of course, there is no end to the many possible hair arrangements, textures and shades. Number 6 is an example of straight, dark hair. In 7 the hair is extra fine and wavy. Curly, middle-toned hair is drawn in 8. In 9 blond, relatively straight hair is shown. Notice that the hair in 10 goes forward from the part line and then back; whereas in 9 the hair goes back from the part.

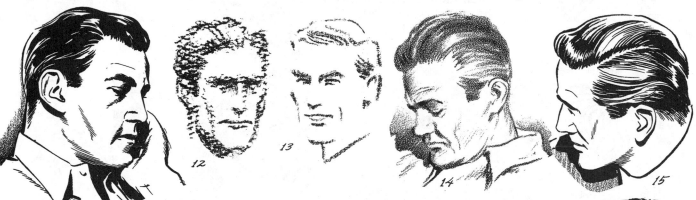

11

12

13

14

15

Regardless of the technique used in drawing hair, it must be made to look soft and pliable. The hairline on forehead and at temples should have a light, informal edging. Male hair lies in pliant strips, conforming to the skull shape beneath. If there is a part, watch for highlights on either side. Usually it is well to have broken lines about the outside contour. Look for the S-curved sweepback from temple to behind the ear.

16

24

23

22

21

20

19

18

17

22

HIDDEN ANGLES

There is tremendous value in looking for a structural pattern in all of art regardless of what it may be. This page is presented as a challenge to creative experimentation.

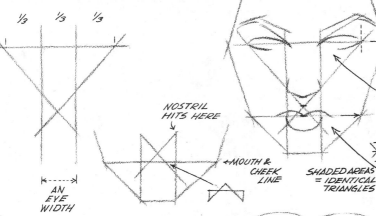

⅓ ⅓ ⅓

AN EYE WIDTH

NOSTRIL HITS HERE

← MOUTH & CHEEK LINE

SHADED AREAS = IDENTICAL TRIANGLES

TRIANGLES IN LINE

HIDDEN CIRCLES

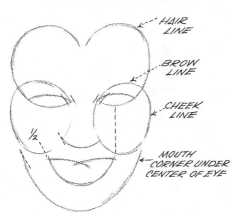

– HAIR LINE

– BROW LINE

– CHEEK LINE

½

← MOUTH CORNER UNDER CENTER OF EYE

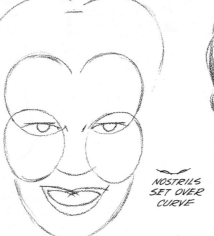

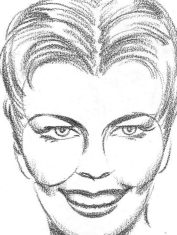

NOSTRILS SET OVER CURVE

THE KITE

a, b, c, d = IDENTICAL TRIANGLES

a b c

d

TOP OF BOTTOM LIP

NOTICE EYE IN TRIANGLE

½

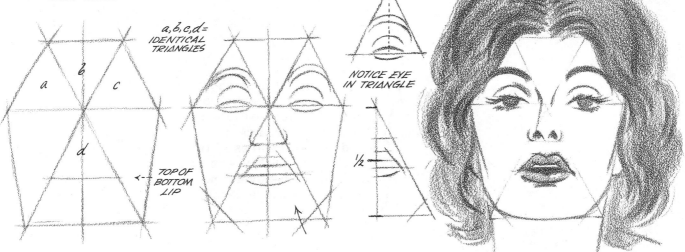

The foreshortened female face from the side is not hard to draw once one understands what is happening. Often the ear is the key as to what parts of the facial features are exposed to view.

FORESHORTENING THE HEAD FROM THE SIDE

First consider two simple bone areas. The protrusion above the eye or the top of the eye-socket is part of the forehead or "frontal" bone. The "malar" or cheek bone also comes into play.

1

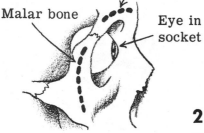

Frontal bone

Malar bone

Eye in socket

2

The extreme rear view which has these two bone regions barely showing.

3

As the head turns, the eyelashes of the upper lid usually come into view first, and possibly the tip of the penciled or extended eyebrow.

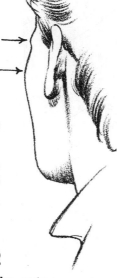

4

From contour alone this position discloses a laughing expression, though the mouth is entirely hidden.

5

A little more turning of the head reveals a bit of the eyelid. Brow may or may not show.

6

Then tip of nose shows, and a small portion of the lips may or may not show, depending upon individual features of the person. Notice ear high (above eye-level) and ear low (below eye-level).

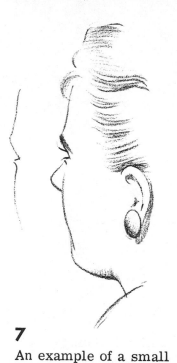

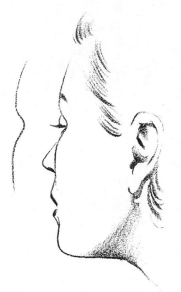

7

An example of a small mouth still not showing, and yet both upper and lower lashes are in evidence beneath a low brow.

8

Heavy lid with white eyeball not drawn owing to its "water-like" contour. This ear is flat to head, but most ears are set out.

9

Heavy lid looking down. Notice S line made by eyebrow and malar bone.

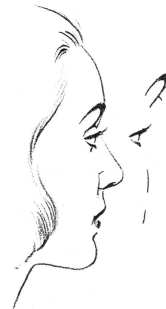

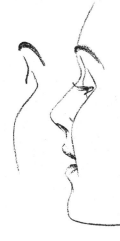

10

Protruding eye prominently displayed. Observe "cut-off" line of cheek area in front of nose base and mouth.

11

Example of emphasized lashes and arched brow coming down to meet line of frontal bone. There's just a suggestion of the pupil. Note broken "cut-off" line of cheek.

12

Prominent cheek line even though face is approaching straight profile position. Socket line drawn pointing toward high brow. See "cut-off" line hiding mouth corner.

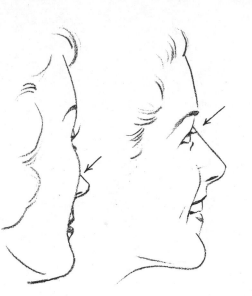

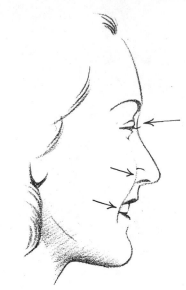

13

Watch how bridge of nose
may run into eye if face is
in semi-profile; whereas
bridge line runs below eye
if face turns away, and
above eye if face nears
complete profile.

14

In this position laughing
eye is drawn close to
"root" of nose at forehead.
Continuous cheek line
intercepts nose and mouth.

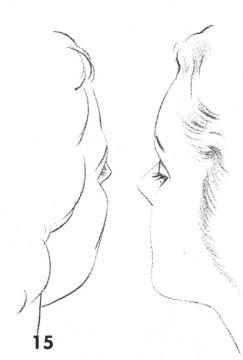

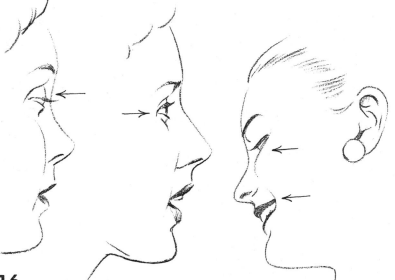

15

Faces foreshortened from
side and top. See how nose
tip "boxes" in eye.

16

Left, eye would be big orb
and wide from front. Right,
eye would be relatively
small from front. Both
these faces are almost in
exact side profile.

17

Face foreshortened from
side and bottom. Notice
peculiar "cut-off" of cheek
line.

THE FEMALE PROFILE IN EASY SEQUENCE

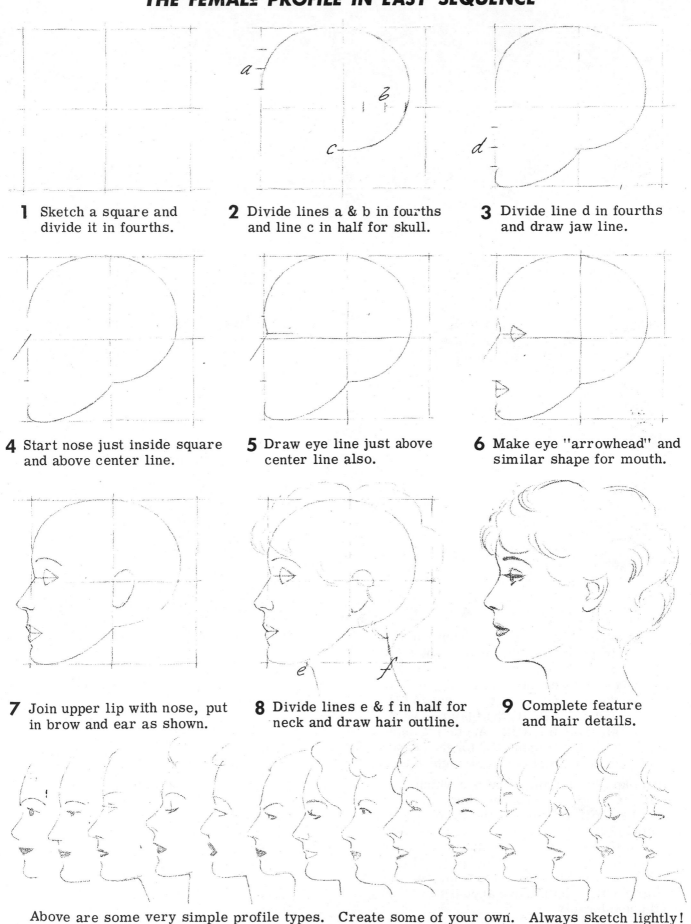

1 Sketch a square and divide it in fourths.

2 Divide lines a & b in fourths and line c in half for skull.

3 Divide line d in fourths and draw jaw line.

4 Start nose just inside square and above center line.

5 Draw eye line just above center line also.

6 Make eye "arrowhead" and similar shape for mouth.

7 Join upper lip with nose, put in brow and ear as shown.

8 Divide lines e & f in half for neck and draw hair outline.

9 Complete feature and hair details.

Above are some very simple profile types. Create some of your own. Always sketch lightly!

When drawing someone's profile be extremely observant of the directions taken by the line parts, also their comparative lengths. In your mind's eye extend the contour lines to better find their angles and shape. Particularly notice the relative slants of foreheads, brows, tops and bottoms of noses. Good portrait drawing comes from a constant comparison of distances.

A B C

When a straight line, above left, is dropped from the brow's apex to the chin, the upper lip nearly always comes well in front of it. In fact, the profile is built on a curve (A) and not with all the features on a straight line (B). Another common error is to push the forehead and chin in front of the straight line (C).

A little-known fact about the eye which applies in profile is that one cannot move the upper lid without the lower lid moving too, though to a lesser degree. Still this is enough to affect the eye's position (see dotted line at right). When face is only slightly foreshortened (far right), closing eye appears to drop considerably.

Seeing "through" lashes, notice how upper lid may carry around and down.

From under, lids are convex.

From above, eye curve is reversed.

Lashes may show on other side of nose.

Line may connect brow and eye.

Depression above inside of eye often catches shadow.

DIFFERENCES IN MALE AND FEMALE PROFILES

1 More males have slight indentions in foreheads than females.

2 As a rule male brows extend out farther than do those of females.

3 Bridge root of female nose is more likely to be rounded, at least to some degree, than males.

4 Male noses tend to be somewhat longer, but only because entire head is a little larger.

5 The male nose is straighter underneath than the average female nose.

6 There is more likely to be a curve between mouth and nose of the female than the male.

7 Overall thickness of male lips is less than female.

8 Male chins tend to be bolder, more pronounced than female chins.

Try incorporating these optional character-
istics in your female fashion heads:
 Heavier upper eyelid
 Longer lashes or pronounced eye rims
 Extra dark around eyes
 Eyes sometimes closer together
 Slight slant to eyes
 Thin nose with nostrils closer
 Sometimes smaller mouth
 Usually passive expression
 Sunken or flat cheek line
 More pointed chin
 Slender neck
 Freer lines — even wispy
 Informal strokes as if
 by accident
Optional male characteristics:
 Often no upper lid
 Sometimes squinty eyes
 Lower brow
 Tapered nose
 Bony cheeks
 Thinner face
 Sophisticated or
 carefree look
 Usually more ragged
 line treatment

THE MALE PROFILE IN EASY SEQUENCE

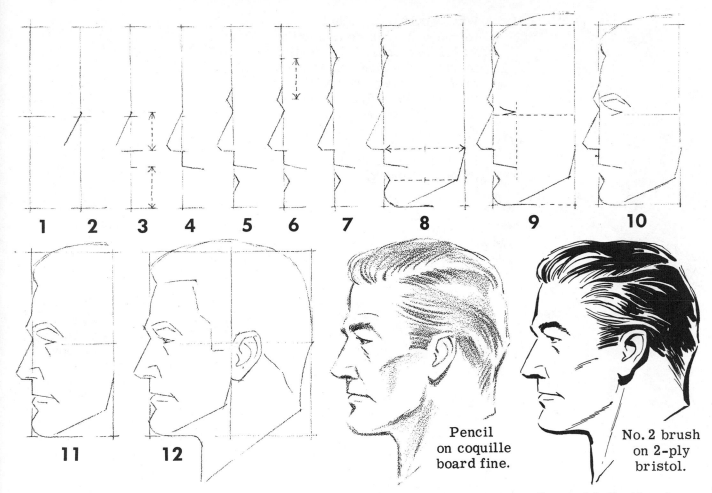

1 2 3 4 5 6 7 8 9 10

Pencil
on coquille
board fine.

No. 2 brush
on 2-ply
bristol.

11 12

Draw a rectangle (1/8 deeper than wide) and divide it in half both ways. Start at left side of rectangle (1). 2. Draw nose line (about 1/5 rectangle's height) with root just above halfway mark. 3. Nose height same as distance from lip to chin; upper lip half of that. 4. Draw lip line. 5. Set in small brow triangle outside of perpendicular and similar lower lip triangle inside of perpendicular. 6. Hair line is nose's height from brow point. 7. Draw another small modified triangle inside perpendicular at hair line. 8. Draw jaw to center head line. Also bottom of chin and top of hair. 9. Draw eye directly above center line. 10. Sketch brow over eye. 11. Add short line beneath eye, two nostril lines, and three lip lines as shown. 12. Complete hair lines, neck, and back of head. Add ear behind center line even with nose. Following are suggested techniques.

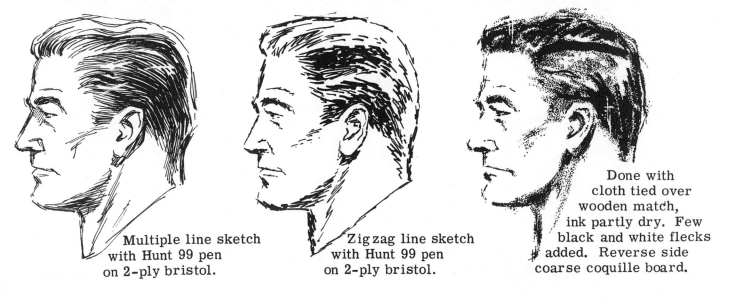

Multiple line sketch
with Hunt 99 pen
on 2-ply bristol.

Zig zag line sketch
with Hunt 99 pen
on 2-ply bristol.

Done with
cloth tied over
wooden match,
ink partly dry. Few
black and white flecks
added. Reverse side
coarse coquille board.

HELPFUL POINTERS IN THE MALE PROFILE

VARIABLE

IN LINE WITH ① ② EACH OTHER ③

FARTHEST LINE FORWARD

FARTHEST LINE BACK

What would be an ideal face to one would not be to another. At left are proposed indention marks for various parts of the profile. Surely they are not the same with all faces. More often than not, marks 1, 2 & 3 are in line with each other. The small retreat under the lip will most likely be the farthest point back.

→ Omitting high lines; accenting low lines.

Strive for freedom of line in your sketching as you progress. Try to break away from long, hard, continuous lines.

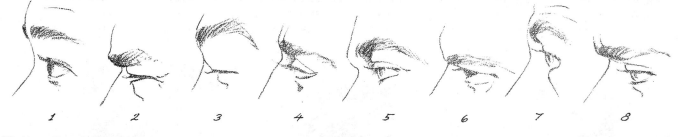

 1 2 3 4 5 6 7 8 9 10 11 12 13 14

Here are a few simple, linear types. 1 & 2 have the profile's bare essentials. Usually it is well to start with the nose, then work up and down from it. There are millions of possibilities!

 1 2 3 4 5 6 7 8

Notice the different brow placements above. Eye shapes and expressions have endless variations. Catalog some of your own making. Observe eye depths, widths, lid formations, wrinkles, etc.

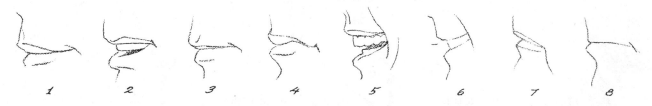

 1 2 3 4 5 6 7 8

The mouth has every bit as much to do with expression as do the eyes. Just the corner turned up or down slightly makes worlds of difference. A short shadow line may suffice beneath lower lip.

RECORDING THE PLANES IN THE MALE HEAD

Diagram labels in figure 1: a, b, c, d, e

Diagram labels in figure 2 (skull): PARIETAL, FRONTAL BONE, INFERIOR TEMPORAL LINE, ZYGOMATIC ARCH, TEMPORAL BONE, NASAL, OCCIPITAL, ZYGOMATIC, MAXILLA, MANDIBLE

Diagram label in figure 3: HOLLOW

1 **2** **3**

Above are the major planes of the face with the underlying frame of bone which causes them. One way of portraying pronounced masculinity is to stress the appearance of the zygomatic arch (cheek bone) c and the hollow beneath it which slants toward the mouth. There is a strip of flesh in the black area of diagram 3 which protrudes as a result of repeated pullings of two facial muscles (indicated above hollow) which lift the mouth corners. Evidence of this usually is recorded in the drawing of a good male head. Check these points in the attending sketches.

Grease pencil on charcoal paper. **8**

4

5 **6** **7**

9

This drawing is done chiefly with straight lines and angles both in contour & plane. Prismacolor 935 pencil on coquille.

10

Notice exceptionally heavy brush lines in head above. Compare this concept with skull structure at top of page.

11

Studies of Lincoln afford excellent opportunity to express marked bone work. Grease pencil on coarse water-color paper.

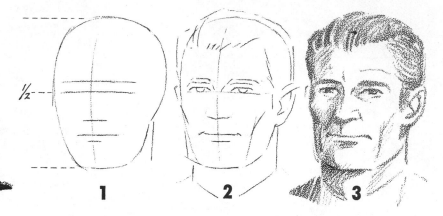

1 **2** **3**

After one has studied and practiced the opening sequences on the female head, he can employ the same essential approaches in drawing the male head. The head of the male reveals more of the underlying bone, is more angular, more rugged. The brows are heavier and usually lower placed. The lip line is thinner, spreads wider. The jaw is heavier and more strongly defined. The neck is thicker. Never start on an individual feature and carry it to completion, but think first of the head as a whole. Indicate feature placement. Go back and forth several times from one feature to another — this will prevent your losing concept of the whole.

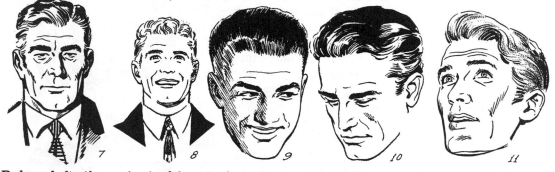

Below, left, the principal key to foreshortening is illustrated. You are looking down into or up into a series of circles upon which the features lie. There is a "show line" and a "disappearing line" in each case. Study the diagram.

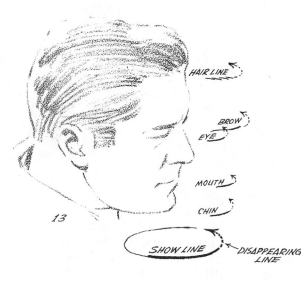

HAIR LINE

BROW
EYE

MOUTH

CHIN

SHOW LINE ← DISAPPEARING LINE

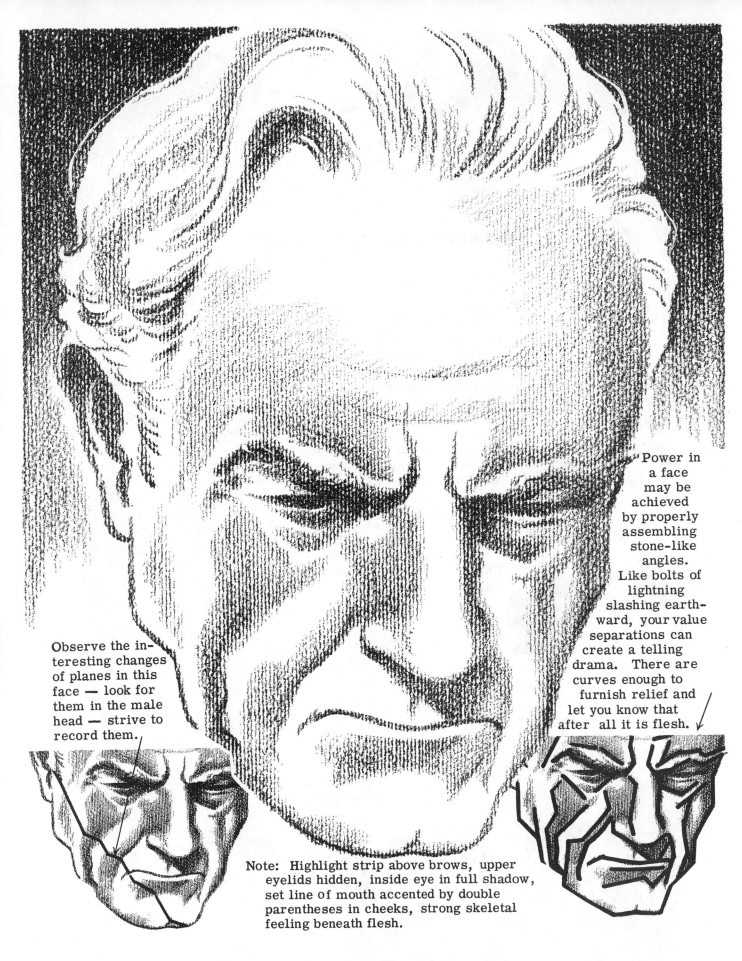

Power in a face may be achieved by properly assembling stone-like angles. Like bolts of lightning slashing earthward, your value separations can create a telling drama. There are curves enough to furnish relief and let you know that after all it is flesh.

Observe the interesting changes of planes in this face — look for them in the male head — strive to record them.

Note: Highlight strip above brows, upper eyelids hidden, inside eye in full shadow, set line of mouth accented by double parentheses in cheeks, strong skeletal feeling beneath flesh.

DRAWING CHILDREN'S HEADS

Points to remember in drawing heads of children:

The face is smaller in proportion to the rest of the head

Back of the head sticks out farther and neck is smaller

Usually the ear is larger proportionately than rest of features

The iris or colored part of the eye approaches adult size and in its small setting is nearly fully exposed

The eyes appear a little wider apart in very small children

Whereas lashes appear longer, brows are much thinner

Early nose is usually upturned; center septum is flatter in babies

Upper lip protrudes at first; mouth has more indention at corners

Chin is less prominent and recedes

Early cheeks are rounder

AGES 1-2 3-5 6-8 12-15 16-18 25-35

36

THE SEMI-CARTOON HEAD

Of course, there are limitless ways of handling a drawing pen. The art student should never be completely content in pursuing just one style of drawing all the time. Trying different approaches can be an exhilarating experience. Here are some examples of line work which border on the humorous but which are not too far from reality. Notice that the treatment is mostly side-by-side line with very little cross-hatch. Too much cross-hatch is susceptible to an over-worked look. Particularly observe the values under the noses, on the sides of the heads and under the chins. A set of lines may so cooperate as to lay down a shadow. Even the thinnest lines should remain healthy and not be like a spider's web. In this instance the blacks were done with the same pen as the rest of the head.

Points to remember in drawing elderly folk:
 Hair thins or turns noticeably white
 Definite lines remain in forehead
 Eyebrows may become sparse or scraggly
 Eyelids have tendency to droop
 Socket bone protrudes as eyes sink back
 Wrinkles form around lower lid pocket
 Slight depression may occur at temples
 Cheek bones become prominent with
 hollow below
 Ears lengthen; lobe hangs pendant-like
 Ball of nose may appear to swell
 Mouth sinks back and wrinkles run off lips
 Flesh drops at jowls
 Chin bone protrudes
 Neck becomes gaunt; skin hangs in drapes

PROPORTIONS OF THE HUMAN FIGURE

The unit of measurement in drawing the human figure is usually a "head's length." The average height is thought of as being 7 1/2 heads. However, race, sex, age and individual physical differences prevent setting down any fixed rules as to anatomical proportions.

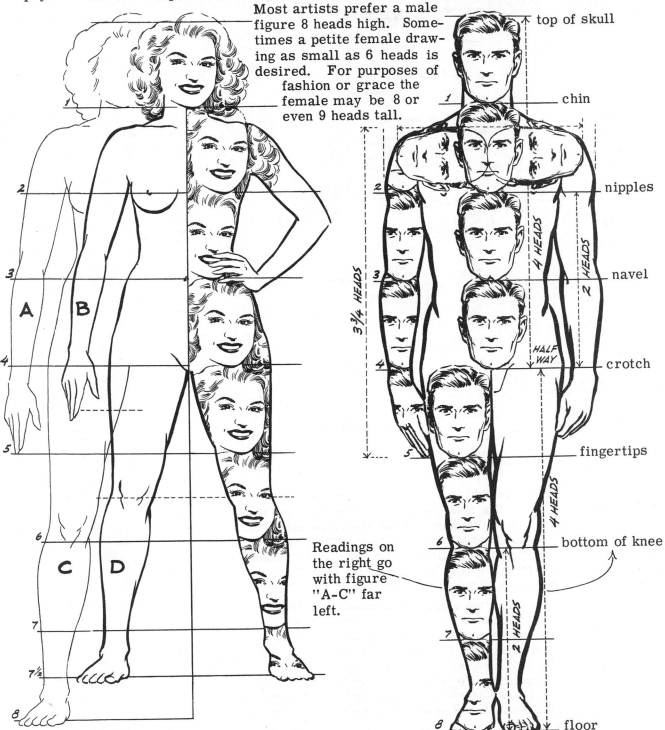

Most artists prefer a male figure 8 heads high. Sometimes a petite female drawing as small as 6 heads is desired. For purposes of fashion or grace the female may be 8 or even 9 heads tall.

Readings on the right go with figure "A-C" far left.

Above is a figure 7 1/2 heads overall. To the left is the same head and torso proportion as in the shorter figure, but the arm and leg have been altered to comply with the 8-head height. Many artists prefer the extra length in the legs. The half-head longer "C" leg is sometimes used with the "B" arm length.

Of course, it is not necessary to draw the repeated row of heads. In this case they are pictured to help retain comparative relationships. First, mark the edge of a paper scrap with your chosen head unit and follow down through your sketch as it is developed. After considerable practice you will be able to sense the proportions.

THE SKELETON BENEATH

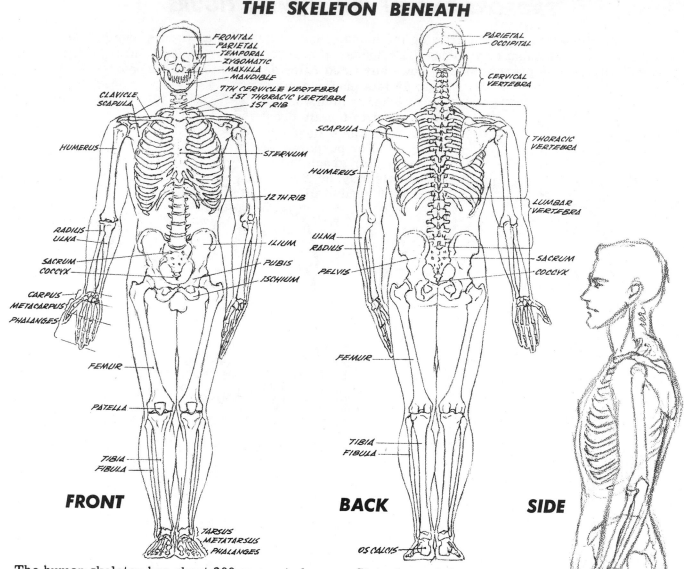

FRONT

BACK

SIDE

Front labels: FRONTAL, PARIETAL, TEMPORAL, ZYGOMATIC, MAXILLA, MANDIBLE, CLAVICLE, SCAPULA, 7TH CERVICLE VERTEBRA, 1ST THORACIC VERTEBRA, 1ST RIB, HUMERUS, STERNUM, 12TH RIB, RADIUS, ULNA, SACRUM, COCCYX, ILIUM, PUBIS, ISCHIUM, CARPUS, METACARPUS, PHALANGES, FEMUR, PATELLA, TIBIA, FIBULA, TARSUS, METATARSUS, PHALANGES

Back labels: PARIETAL, OCCIPITAL, CERVICAL VERTEBRA, SCAPULA, HUMERUS, THORACIC VERTEBRA, LUMBAR VERTEBRA, ULNA, RADIUS, PELVIS, SACRUM, COCCYX, FEMUR, TIBIA, FIBULA, OS CALCIS

The human skeleton has about 200 separate bones. Sixty-four of these are in the hands and arms alone. The chief concern of the art student is to acquaint himself with the "show" bones that have bearing on the surface forms. They are important and not as difficult to learn as one might first imagine. The long bones, found mostly in the four limbs, play the biggest role in body movement. Besides being strong support bones, muscles convert them into marvelous mechanical levers. Their smooth extremities are designed for articulation.

The plate-like bones such as the skull and ilium of the pelvis serve in a protective capacity for delicate tissues and organs beneath. In addition, a few powerful muscles find their origin on these bones like the temporal muscle on the side of the skull which raises the lower jaw, and the thigh and hip-joint muscles which have their origin on the crest of the ilium. The cage of ribs forms a basket protection for life-propelling organs, besides being elastic for breathing expansion and contraction. Then we have long bones, plate bones, and thirdly, irregular bones found in the face, spine and in the hands and feet.

There are four kinds of bone joints. Ball and socket joints have a rounded head fitting into a cup-like cavity (shoulder and hip). Hinge joints have a forward and backward movement (elbow and knee). Pivot joints (as occur between the head of the radius and the radial notch of the ulna — outside of elbow) allow for a twisting action. Lastly, gliding joints have a limited movement (in spine and between carpal and tarsal bones in hand and foot). Other sections will deal further with bone functions.

THE SIMPLIFIED FIGURETTE

Commence by drawing the simplified figurette. Use the two trapezoids for the front torso and the two ovals for the side.

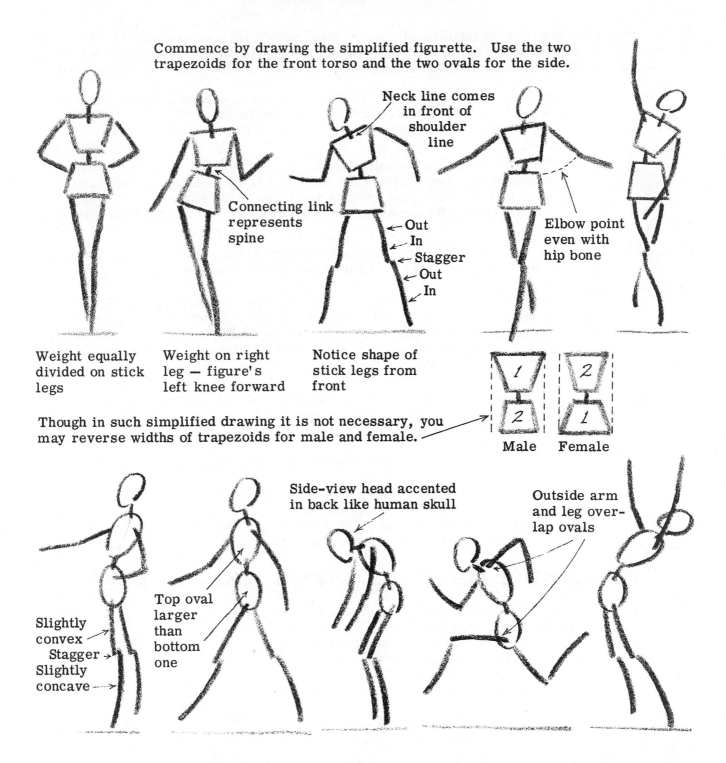

Neck line comes in front of shoulder line

Connecting link represents spine

←Out
←In
←Stagger
←Out
←In

Elbow point even with hip bone

Weight equally divided on stick legs

Weight on right leg — figure's left knee forward

Notice shape of stick legs from front

Though in such simplified drawing it is not necessary, you may reverse widths of trapezoids for male and female.

Male Female

Side-view head accented in back like human skull

Outside arm and leg overlap ovals

Slightly convex
Stagger →
Slightly concave

Top oval larger than bottom one

The reason that trapezoids are used for the front figure and ovals for the side figure is that these two shapes represent the <u>overall</u> bone structure of the torso from front and side

STARTING FROM SCRATCH TO DRAW THE HUMAN FIGURE

Oftentimes a truth is established best by showing several approaches to it. On these forthcoming pages different simplified devices will be presented which will be helpful in understanding how the human body is put together. Only non-technical terms are used.

Before one can ever learn to draw the surface anatomy, he should find out something of the understructure. By remembering "TUM" with the "U" upside down, one can associate a number of important facts with it.

The "T" is simply the collarbones and spine. In the straight front view they cross (though not attached; the spine is a few inches behind) at the pit of the neck marked "x." This "x" is a significant point in the human framework for the artist. He moves out from here in determining many figure factors.

The inverted "U" represents the rib-cage area. The horizontal crossbar of the "T" intersects a small part of the curve at the top.

The "M" becomes the hip region and serves a triple purpose. The center portion (the "V" of the "M") depicts the general structure beneath known as the pelvic bone. Notice the "V" is flattened considerably on the bottom. The middle of the "V" suggests the stomach's surface area. The outside of the "M" defines the sides of the hips.

Four notations may be made at the check points (1 through 4):

1 There is a slight hollow here just inside the ball of the shoulder. This exists on everyone. It occurs just above and on the inside of the armpit.

2 If ribs show at all, and they often do, it's along here. The flesh is thin at this place.

3 The hip bone nearly always is in evidence here. This is another vitally important point in figure structure.

4 The outside knob of the upper thigh bone. This is still another landmark in drawing the human form.

COMPARATIVE DIFFERENCES BETWEEN FEMALE AND MALE

The first figure at the right, the female, is noticeably more narrow at the shoulders than the hips. The reverse is true of the male. The female "T" and the inverted "U" are smaller, but the female "V" inside the "M" does not likewise diminish. It flares wider and may not be quite as tall as the male.

The crossbar (the shoulder line of the collarbones) may rock as a seesaw on point "x." There is mobility here. The "U" and the "M" sections are unable to change their basic shape, but movement does occur between each of them in the stem of the "T", the lower center of the spine.

Observe how the outsides of the "M" (here dotted lines) in the male are parallel, whereas in the female they spread outward as they go down.

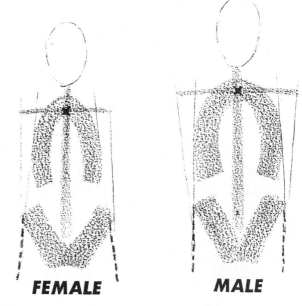

FEMALE **MALE**

THE CHANGES OF DIRECTION IN THE FIGURE

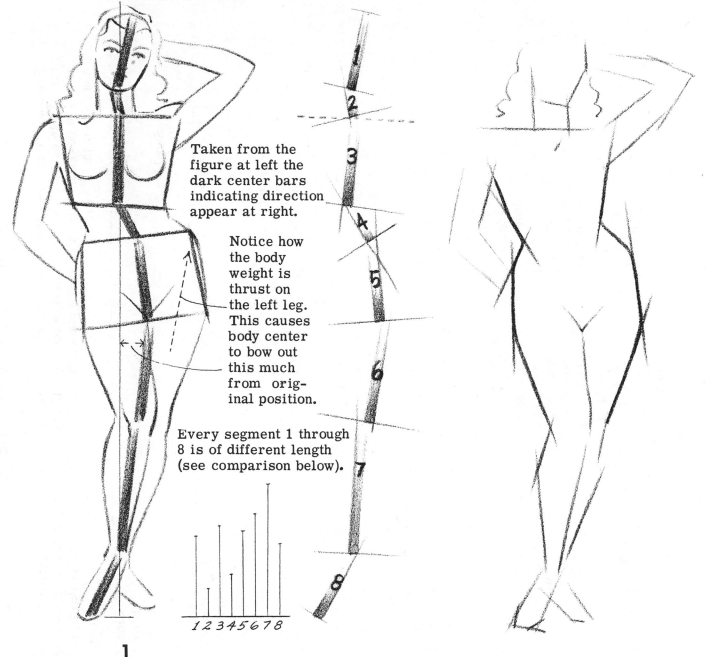

Taken from the figure at left the dark center bars indicating direction appear at right.

Notice how the body weight is thrust on the left leg. This causes body center to bow out this much from original position.

Every segment 1 through 8 is of different length (see comparison below).

1 2 3 4 5 6 7 8

1

Look for changes of direction in the human figure. If the body weight is shifted on one foot or the other, there will always be some change of direction running through the body.

A line running through the pit of the neck and drawn perpendicular to the floor lets you know where the feet must be placed. If both feet are on one side or the other of this line then figure will be off balance.

2

There are eight static areas or sections of the body that in themselves do not move. However, where these join on to the other, a change of direction may occur. The two of the eight that possess some degree of pliability are the neck "2" and the mid-section designated as "4". The others are rigid.

3

There are certain lines in the contour of the body that tend to be straight. If the entire body were curved it would lack in the appearance of strength. The outside contour itself then has interesting changes of direction. Observe the variety of the line lengths in this contour.

THE BASIC LINES OF THE FIGURE EXTENDED

The purpose of these diagrams is for observation only. They are not intended as a method of drawing. By the simple extension of lines found in the ideal figure, one becomes aware of the marvelous symmetry, balance and power incorporated in the masterful design. The very structural lines themselves bespeak maximum strength.

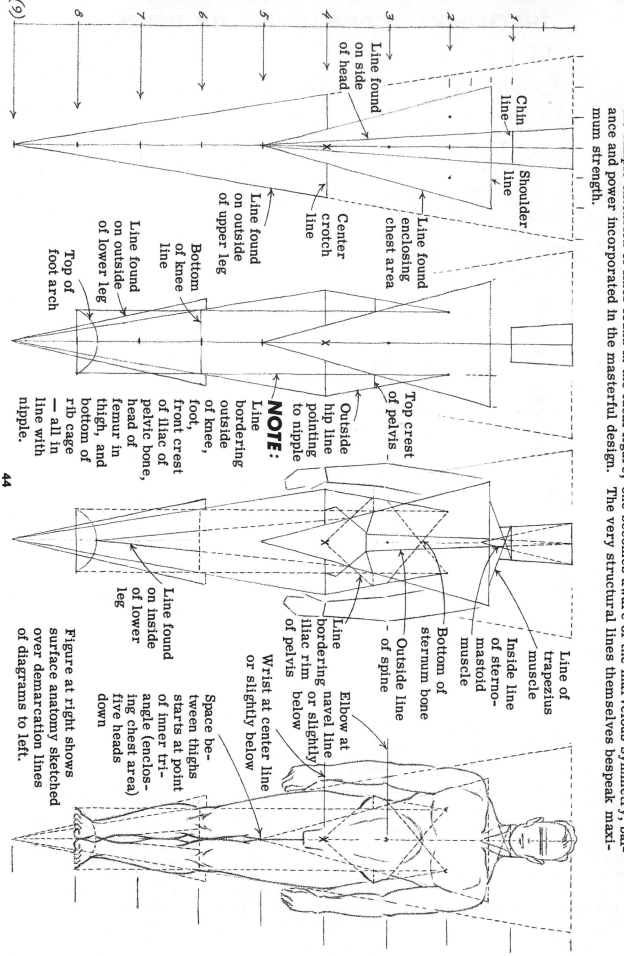

(9)

Chin line

Shoulder line

Line found on side of head

Line found enclosing chest area

Center crotch line

Line found on outside of upper leg

Bottom of knee line

Line found on outside of lower leg

Top of foot arch

Top crest of pelvis

Outside hip line pointing to nipple

NOTE:

Line bordering outside of knee, foot, front crest of iliac of pelvic bone, head of femur in thigh, and bottom of rib cage — all in line with nipple.

Line of trapezius muscle

Inside line of sterno-mastoid muscle

Bottom of sternum bone

Outside line of spine

Line bordering navel line iliac rim or slightly below

Elbow at center line or slightly below

Wrist at center line or slightly below

Space between thighs starts at point of inner triangle (enclosing chest area) five heads down

Line found on inside of lower leg

Figure at right shows surface anatomy sketched over demarcation lines of diagrams to left.

44

BUILDING ON *THE DOUBLE TRIANGLE*

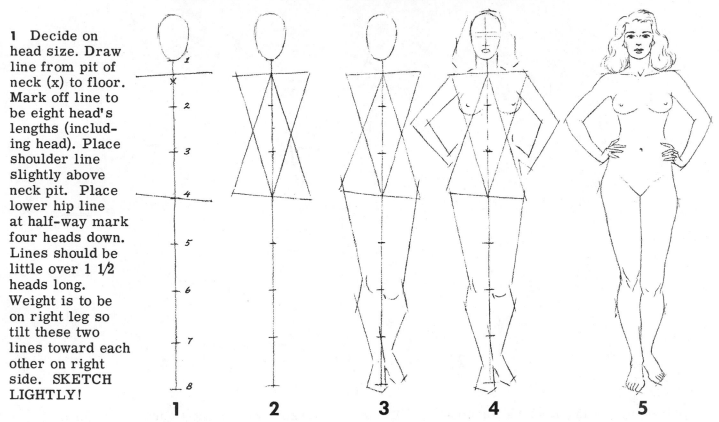

1 Decide on head size. Draw line from pit of neck (x) to floor. Mark off line to be eight head's lengths (including head). Place shoulder line slightly above neck pit. Place lower hip line at half-way mark four heads down. Lines should be little over 1 1/2 heads long. Weight is to be on right leg so tilt these two lines toward each other on right side. SKETCH LIGHTLY!

2 Make triangles overlapping each other with center points on shoulder and hip lines as shown.
3 Sketch leg outlines. Knee of straight leg comes just above 6th marker. Bent knee comes below.
4 Block in arms. Nipples come at 2nd marker. Indicate neck, hair and facial features.
5 Finish sketch over lightly-drawn framework of first four steps. Transfer finish if necessary.

The chief value of the double triangle exercise is to help one become conscious of the four extremities of the torso and their relation to one another. We think of the lower hip bone (really the top outside of the thigh bone) as a part of the torso. Actually the outside triangle points may be rounded somewhat, allowing the points themselves to go outside the body on occasion. There may be some modification necessary through the waist. The high hip bones on either side of the navel will jut out a little from the triangle lines.

The idea of the triangles assists in calling attention to the diagonals which run through the figure's trunk. Study the sections on arms and legs in order to draw them properly.

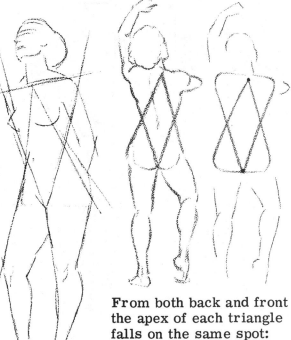

From both back and front the apex of each triangle falls on the same spot: the pit of the neck and the crotch of the figure. Notice above how the top spot is switched from the spine.

APPROACHING FIGURE DRAWING IN DIFFERENT WAYS

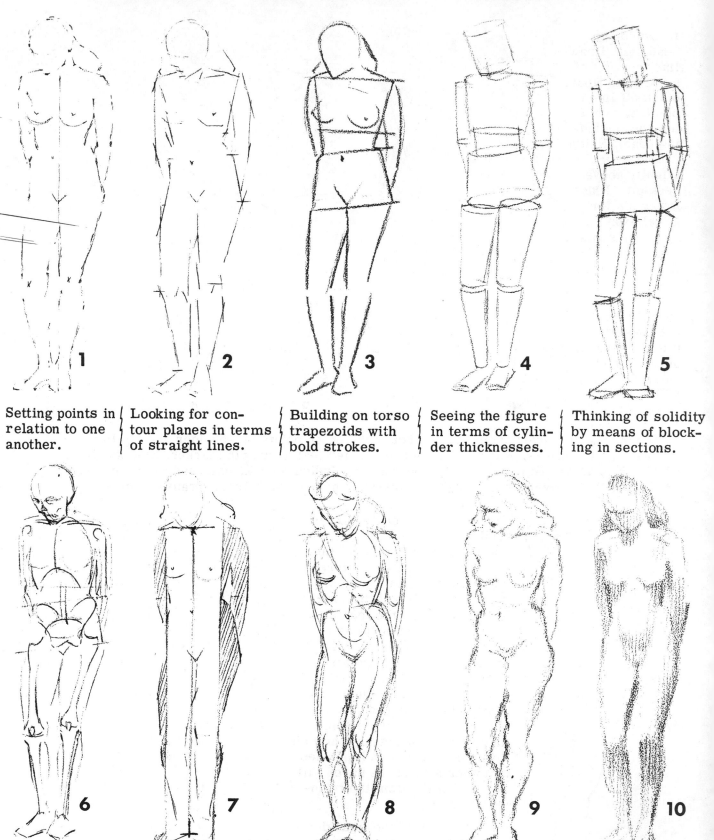

1 Setting points in relation to one another.

2 Looking for contour planes in terms of straight lines.

3 Building on torso trapezoids with bold strokes.

4 Seeing the figure in terms of cylinder thicknesses.

5 Thinking of solidity by means of blocking in sections.

6 Visualizing the skeleton beneath the surface.

7 Seeing what remains on either side of imaginary plumb lines.

8 Feeling sweep of line that runs through figure.

9 Expressing freedom in contour exaggeration.

10 Thinking in terms of light and shadow throughout figure.

ARM MOVEMENT AND BODY PROPORTIONS

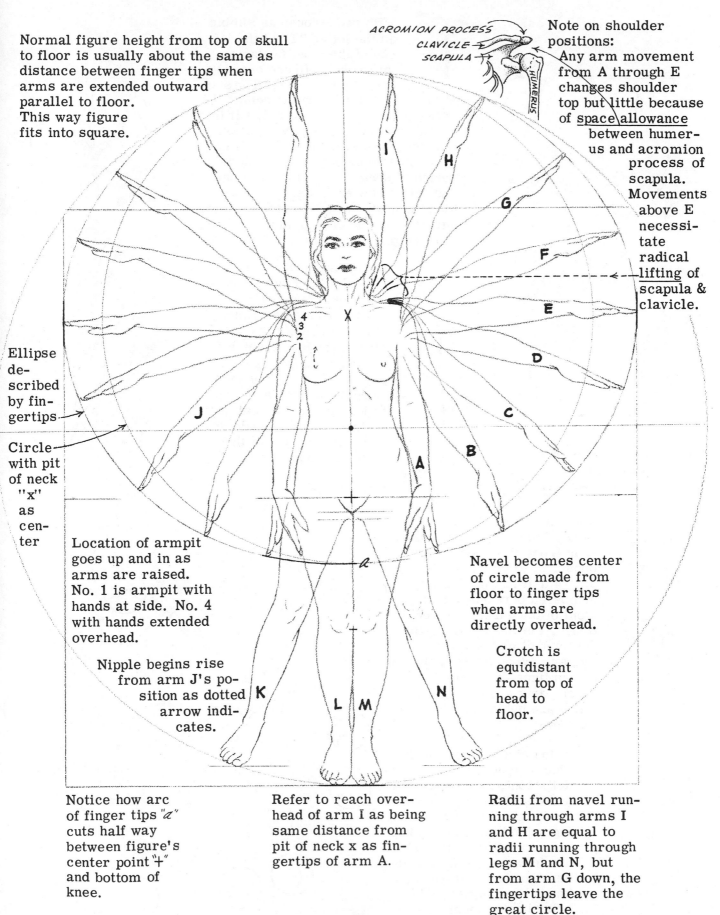

Normal figure height from top of skull to floor is usually about the same as distance between finger tips when arms are extended outward parallel to floor. This way figure fits into square.

ACROMION PROCESS
CLAVICLE →
SCAPULA →
HUMERUS

Note on shoulder positions: Any arm movement from A through E changes shoulder top but little because of space allowance between humerus and acromion process of scapula. Movements above E necessitate radical lifting of scapula & clavicle.

Ellipse described by fingertips →

Circle with pit of neck "x" as center

Location of armpit goes up and in as arms are raised. No. 1 is armpit with hands at side. No. 4 with hands extended overhead.

Nipple begins rise from arm J's position as dotted arrow indicates.

Navel becomes center of circle made from floor to finger tips when arms are directly overhead.

Crotch is equidistant from top of head to floor.

Notice how arc of finger tips "a" cuts half way between figure's center point "+" and bottom of knee.

Refer to reach overhead of arm I as being same distance from pit of neck x as fingertips of arm A.

Radii from navel running through arms I and H are equal to radii running through legs M and N, but from arm G down, the fingertips leave the great circle.

47

THE PRINCIPLE OF THE "T"

With two strokes as simple as the letter "T" at the left one of the most fundamental truths of figure drawing can be illustrated. The stem of the T seems to be going behind the crossbar at the top. You may tilt this crossbar so that it nearly parallels the stem, and still the stem will appear to be going behind it. Look at the series of seven lines in the arc below and notice how each disappears behind the next. Watch for these on the surface contour of your model. Thus, lines help to define form.

Everything that one sees in real life which has edges takes on dimension because of this simple principle. Muscles crisscross each other over bones which do the same thing (see example sketch of arm at right). Even before one ever learns to identify anatomical parts of the body, he should seek to record the T's of the edges by sheer observation.

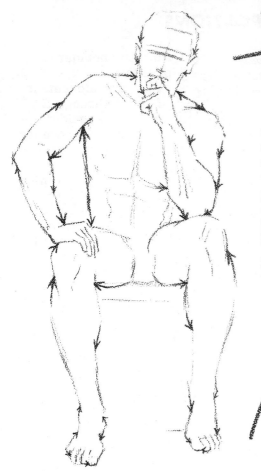

In the sketch above each line which will disappear behind the next has an arrow.

The various external sections of the body are usually in front of or behind the ones next to them. In the diagram at left the lighter, numbered portions are in front of the darker portions. Hence, the lines defining the darker will go behind the lighter. When drawing the human figure ask yourself which parts are closer and which are behind and farther away.

In the circle insets at the right are details of the model's contour. The dotted arrows take you in to where the "action" of one line going behind the other is happening. All the parts which are forward, head, shoulders, breasts, thighs and knees have lines which are going behind them.

48

STEP-AT-A-TIME SKETCHING

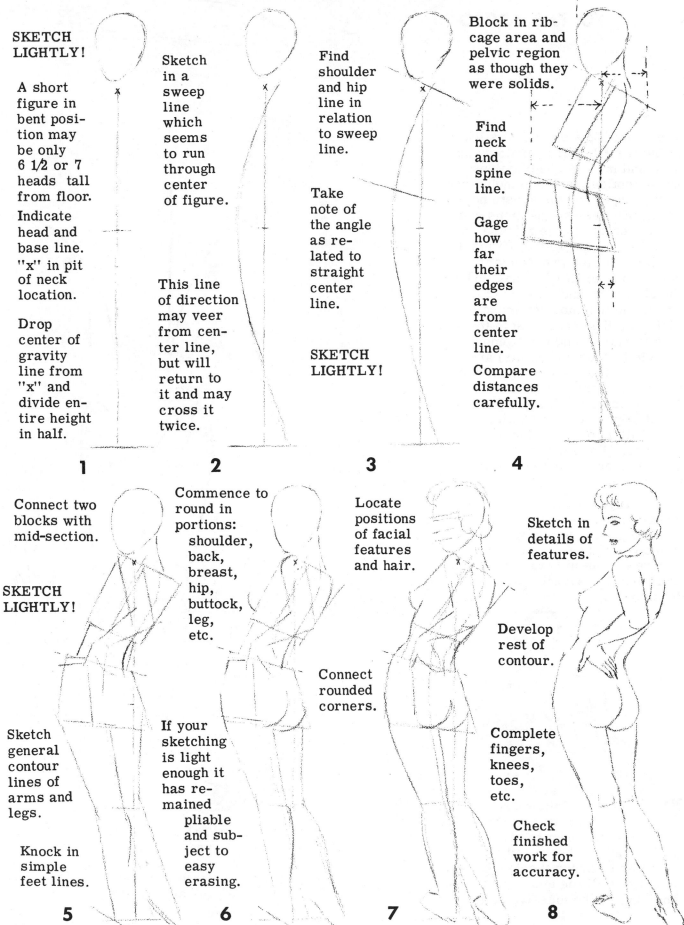

SKETCH LIGHTLY!

A short figure in bent position may be only 6 1/2 or 7 heads tall from floor.

Indicate head and base line. "x" in pit of neck location.

Drop center of gravity line from "x" and divide entire height in half.

1

Sketch in a sweep line which seems to run through center of figure.

This line of direction may veer from center line, but will return to it and may cross it twice.

2

Find shoulder and hip line in relation to sweep line.

Take note of the angle as related to straight center line.

SKETCH LIGHTLY!

3

Block in ribcage area and pelvic region as though they were solids.

Find neck and spine line.

Gage how far their edges are from center line.

Compare distances carefully.

4

Connect two blocks with mid-section.

SKETCH LIGHTLY!

Sketch general contour lines of arms and legs.

Knock in simple feet lines.

5

Commence to round in portions: shoulder, back, breast, hip, buttock, leg, etc.

If your sketching is light enough it has remained pliable and subject to easy erasing.

6

Locate positions of facial features and hair.

Connect rounded corners.

7

Sketch in details of features.

Develop rest of contour.

Complete fingers, knees, toes, etc.

Check finished work for accuracy.

8

JOINING ARMS AND LEGS TO THE TORSO

DELTOID BICEPS

PECTORALIS
MAJOR

TRICEPS

The appendages don't just stick on to the trunk but are "grafted" by bone and muscle combinations. First, notice the two standby trapezoid shapes for the chest and hips which will receive the arms and legs. Secondly, see how the ribcage and pelvis (dotted) fit inside. Next, follow the grooves (arrows) rolling off the lifted arms, under the shoulders and into the chest. Thus, the top shoulder muscle (deltoid), the chest muscle (pectoralis major) and the stomach muscle (rectus abdominis) are defined like a large wedge. All of this is discernible on the surface of the completed figure. In passing observe the neck width as being similar to that of the stomach muscles. (For further study of the shoulder's place in "grafting" the arm see p. 70 ff.).

Even though the bottom trapezoid can be envisioned helpfully, actually the big front leg muscles attach to the pelvic bone inside, leaving a groove rolling in toward the crotch. Compare this with the arrowed lines described on the front of the chest.

SARTORIUS RECTUS FEMORIS

When the arms are lowered, the deltoids round over like extended ledges. The arms seem to come out from underneath. The armpit is somewhat of a center point for the deltoid's arc. The origins of all the upper arm muscles are shielded by the massive deltoid's covering.

The upper arm appears to tuck under from any position. See additional diagrams in the sections specifically dealing with the arms and legs.

BONE AND MUSCLE PROMINENCE IN THE CHEST

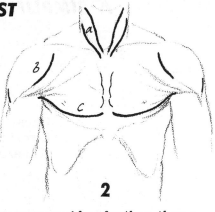

1

Muscles from the chest into the arm are in a sense "woven" basket-like when viewed from beneath. Note the "over and under, over and under" starting with the top arrow.

2

As we consider further those muscles that concern the artist most in the upper torso, we find the above (black lines) showing themselves on the surface. The neck's sterno-mastoid (a), the deltoid's inner outline (b) and the bottom of the chest's pectorlis major (c) -- all are visible.

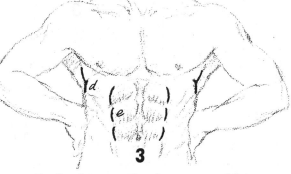

3

In the lower chest area, evidence of the serratus magnus coming off the eight upper ribs (d) and the rectus abdominis (e) manifest themselves in a well-developed chest.

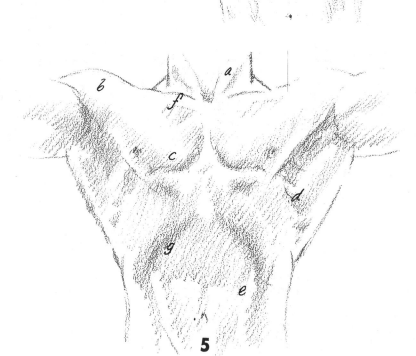

5

Check out these "show points" which are discussed on this page in the above sketch. Remember them!

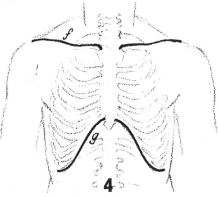

4

Bone lines that have a way of getting attention are the clavicles (f) and the bottom of the ribcage (g).

A SIMPLIFIED GUIDE — 12 STANDARD POSITIONS

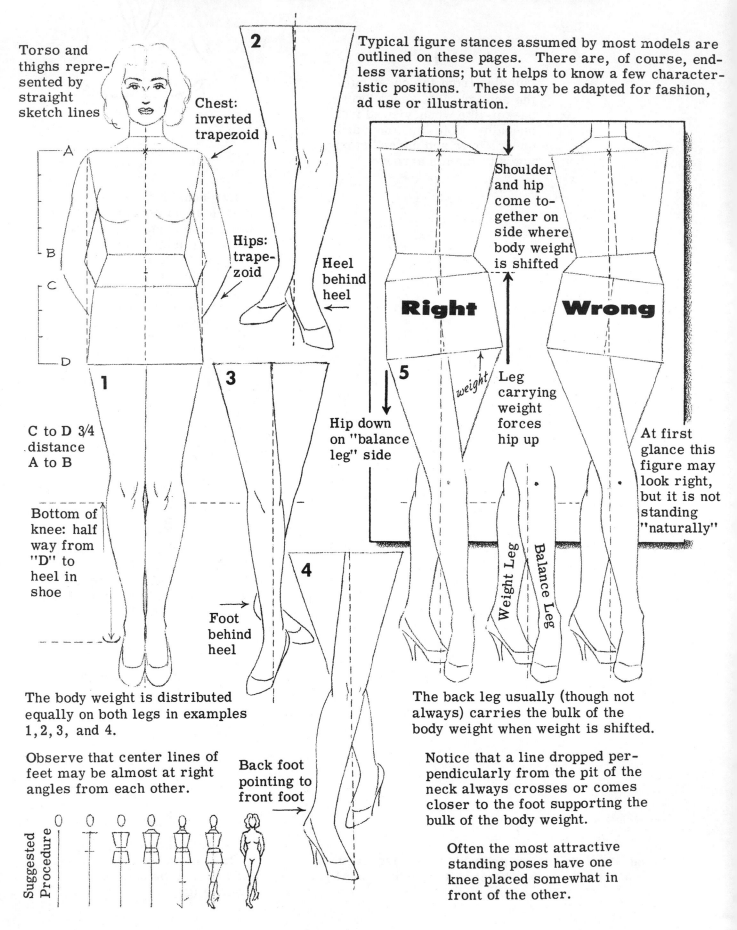

Torso and thighs represented by straight sketch lines

Chest: inverted trapezoid

Hips: trapezoid

Heel behind heel

2

Typical figure stances assumed by most models are outlined on these pages. There are, of course, endless variations; but it helps to know a few characteristic positions. These may be adapted for fashion, ad use or illustration.

Shoulder and hip come together on side where body weight is shifted

Right **Wrong**

A B C D

1

C to D 3/4 distance A to B

Bottom of knee: half way from "D" to heel in shoe

3

Foot behind heel

4

Hip down on "balance leg" side

weight

Leg carrying weight forces hip up

5

At first glance this figure may look right, but it is not standing "naturally"

Weight Leg Balance Leg

The body weight is distributed equally on both legs in examples 1, 2, 3, and 4.

Observe that center lines of feet may be almost at right angles from each other.

Back foot pointing to front foot

The back leg usually (though not always) carries the bulk of the body weight when weight is shifted.

Notice that a line dropped perpendicularly from the pit of the neck always crosses or comes closer to the foot supporting the bulk of the body weight.

Often the most attractive standing poses have one knee placed somewhat in front of the other.

Suggested Procedure

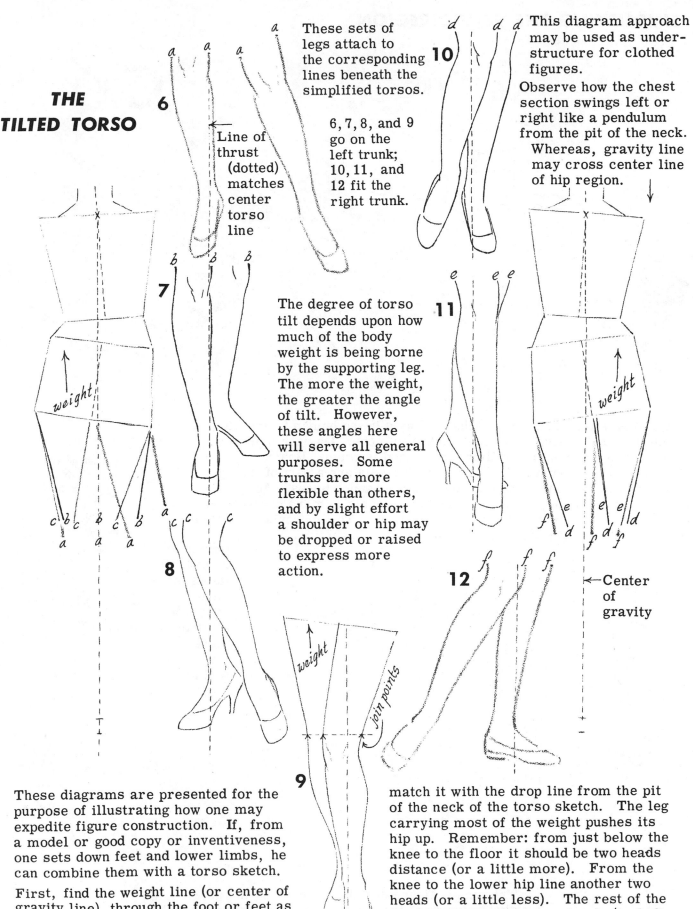

THE TILTED TORSO

6

These sets of legs attach to the corresponding lines beneath the simplified torsos.

6, 7, 8, and 9 go on the left trunk; 10, 11, and 12 fit the right trunk.

Line of thrust (dotted) matches center torso line

7

8

The degree of torso tilt depends upon how much of the body weight is being borne by the supporting leg. The more the weight, the greater the angle of tilt. However, these angles here will serve all general purposes. Some trunks are more flexible than others, and by slight effort a shoulder or hip may be dropped or raised to express more action.

9

join points

10

This diagram approach may be used as understructure for clothed figures.

Observe how the chest section swings left or right like a pendulum from the pit of the neck.

Whereas, gravity line may cross center line of hip region.

11

12

Center of gravity

These diagrams are presented for the purpose of illustrating how one may expedite figure construction. If, from a model or good copy or inventiveness, one sets down feet and lower limbs, he can combine them with a torso sketch.

First, find the weight line (or center of gravity line) through the foot or feet as they seem to support the body above. Then match it with the drop line from the pit of the neck of the torso sketch. The leg carrying most of the weight pushes its hip up. Remember: from just below the knee to the floor it should be two heads distance (or a little more). From the knee to the lower hip line another two heads (or a little less). The rest of the figure on up another four heads (including the actual head itself).

SIMPLIFYING THE PELVIC REGION

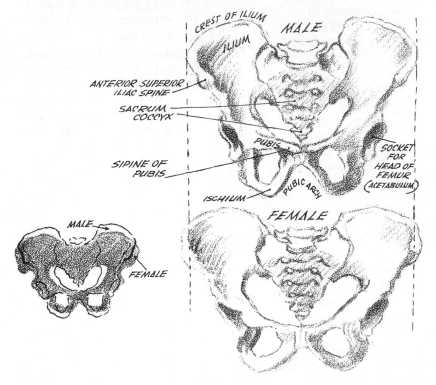

CREST OF ILIUM

MALE

ILIUM

ANTERIOR SUPERIOR ILIAC SPINE

SACRUM
COCCYX

PUBIS

SIPINE OF PUBIS

ISCHIUM

PUBIC ARCH

SOCKET FOR HEAD OF FEMUR (ACETABULUM)

FEMALE

MALE

HIGHER

FEMALE

WIDER

WIDER

MALE

FEMALE

The pelvis is the important mechanical axis in the human frame. It is a basin-like ring of five stout bones fused into one. On each side is a haunch bone made up of the ilium, pubis and ischium. Behind are the other two, the sacrum and coccyx, which really are a part of the spine being wedged into and firmly united with the haunch bones. Above are the male and female pelves compared. The male is more narrow and compact; the female wider and more spacious. The abbreviated sketch forms at upper right prove helpful in figure construction.

PELVIC BONE (FRONT)

INDENTION
PROTRUSION
PROTRUSION
INDENTION
INDENTION
PROTRUSION

FEMUR

Design at right facilitates movement of leg bone. See allowance (arrows below) for ball and socket.

Try simple figure sketching, utilizing the abbreviated sketch forms of the pelvic bone. Iliac ring nearest you gets flatter as figure turns. These abbreviated forms are not to be used in a straight side-view figure.

PELVIC BONE (REAR)

SOCKET
BALL
NECK

FEMUR

FURTHER DIFFERENCES BETWEEN MALE AND FEMALE HIP SECTIONS

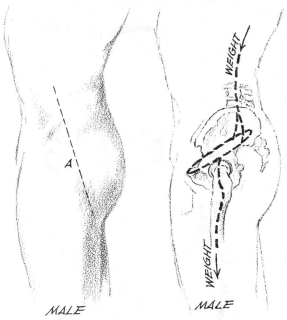

MALE MALE

At left see how upper body weight on spinal column is transferred into pelvis and on to shaft of femur in leg. The dotted ring is the thickest part of the entire pelvic bone.

The bowl-like iliac discs that rise on the sides protect the lower internal organs. The ischium rings at the bottom support the body when seated.

FEMALE FEMALE

At the right are two side view comparisons of the male and female pelvic bones. Not only does the female pelvis tilt forward, but the anterior superior iliac spine extends outward (black area); whereas the spine of the pubis underneath retreats. Also the sacrum at the rear angles out considerably more than the male. Besides being taller (black extension), the male structure is more perpendicular. These differences manifest themselves in the external hip carriage (see A and B in diagrams above).

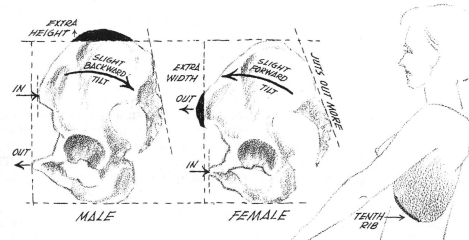

MALE FEMALE

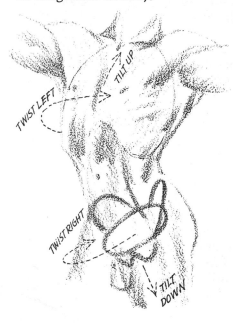

Refer to the sketch at the left which emphasizes independent action between the chest area and the pelvic region. Not only may the two sections twist in different directions, but one may incline upward, while the other may tip downward. Thus, figure action must first be registered in the trunk before it can be relayed through the appendages.

In the simplified outline at the right observe the two shaded areas. The front line of the thigh slopes toward the iliac crest. The other prominence which many times shows on the surface, the tenth rib: if continued, its line would coincide with the top of the buttock. Remember these torso zones. They help in figure drawing.

USING THE ABBREVIATED BONE FORMS

Here is a skeletal breakdown and simplification showing the use of abbreviated bone forms. The black strips on the far right are the bone parts which are likely to have direct bearing on the surface anatomy. They may be located on the completed torso at upper left.

At right is this minimun framework upon which the figure is constructed. Observe relative ribcage and pelvic bone sizes.

At left notice the dotted center ring, also the loops of the ilium above and the ischium below.

Assembling the the pelvis form is simple. Check with the detailed bone formation.

MOBILE AREA

MOBILE AREA

STERNO-MASTOID MUSCLE
TRAPEZIUS MUSCLE
CLAVICLE BONE
DELTOID MUSCLE
STERNUM BONE
THORAX (24 RIBS)
ABDOMINAL ARCH (LINE OF FALSE RIBS)
LINEA ALBA
RECTUS ABDOMINIS MUSCLE
CREST OF ILIUM (PELVIC BONE)
ANTERIOR SUPERIOR ILIAC SPINE
POUPART'S LIGAMENT
TENSOR FASCIAE FEMORIS MUSCLE
GREAT TROCHANTER OF FEMUR BONE
VASTUS EXTERNUS MUSCLE

As illustrated in the above skeletal interior, the chest region is to be thought of as a solid mass. As such it may turn or twist on the flexible stem of the spinal column but in itself is fixed. The same is true with the pelvic region; it may be tilted or turned, but it must move as a unit. On the other hand, the backbone is composed of flexible joints, which discs with cartilage cushion inserts are more moveable between the chest and head, and between the chest and pelvis.

The rib-cage has more bones in it that are near the skin surface than does the formation of the pelvis. Because the muscle fibers in the hips are mostly in bundles, and the muscle fibers around the chest are in sheets, one cannot draw a pelvic bone and get the hip shape as easily as one can draw the rib-cage and get the chest shape. However, in one sense, the ball and socket joints of the upper arm bones widen the shoulder area just as the ball and socket joints of the upper leg bones widen the hips.

Above are listed the bones and muscles which have to do with the torso's immediate exterior. Discern how each part exerts itself on the surface.

At right notice how the chest seats itself into the midsection, and the thighs receive the pelvic region.

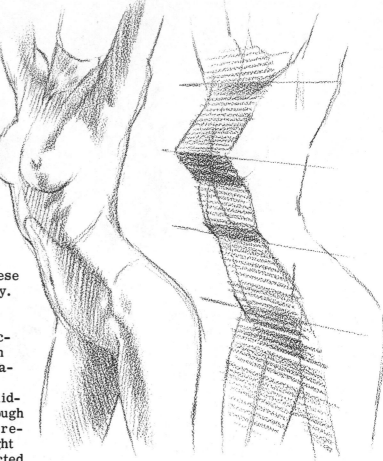

The third dimension of depth in the human figure is best acquired by depicting the existing planes. These planes are not flat with sharp edges, but they are figured to be that part of the anatomy which is mostly front, or side, or back, or top or bottom. Light and shadow are essential, but these are in no short supply. At left the source of light is mainly from above; hence, the sectional forms are seen to "turn under" in shadow. At right notice the "edge" running midway up and down through the figure. This is a result of strong backlight with noticeable reflected light in front. Even though no actual edge occurs, there is a change in shape caught by the shadow. Therefore, we know we are dealing with subdivisions in the figure which are third dimensional. Changes of plane indicate solidity.

At left values are proportioned to tell of that part of the head, neck, arms, torso and lower limbs which are facing front. Since a cylinder or ball is rounded but since there is a demarcation for light and shadow, then planes are contrived to demonstrate solidity. Establishment of the chest and hip blocks (above) helps.

LINES OF DIRECTION, SWEEP AND ACTION

All the dark arrows in the sketch at the right are a part of the figure's contour. Each points to another arrow separated by a dotted line. Not all poses will so align themselves, but very often there are follow-through lines of direction which may be pleasingly picked up and emphasized elsewhere in the composition. The point being this: what are the lines in your subject doing in relation to the other lines? This system of thinking when drawing will take one through the entirety of the subject rather than permitting him to become imprisoned in detail.

Whereas at left the concern is with the outline of the figure, at right the sweep that runs through is stressed. This sweep may be detected wholly within the framework as in figure "2" or it may go across the frame from one side to the other "3." The artist may lightly throw on his paper the lines of sweep and then build around them by locating the head position, neck line, shoulder line, hip line, elbow and knee positions, etc.

It also helps (at left) to recognize the "set" of the body sections in relation to one another. The neck is not set perpendicularly nor are the hips.

A figure which is in the act of moving may still be interpreted in terms of line direction and sweep as well as the set of the body sections.

59

PUTTING STRUCTURAL PRINCIPLES TO WORK

Effort spent in understanding interior construction will pay off when completed figure illustration is needed. Often we hear, "But it just doesn't look right." Usually the problem is one of proportion and failure to allow room for normal anatomical arrangement inside. It is paradoxical in a way, nothing seems more difficult to draw than humanity, yet we live in a sea of it and -- we are one of them!

BALL OF SHOULDER

RIB CAGE

ABDOM. ARCH

PELVIC CREST

THIGH BONE

One cannot intricately draw internal bone or muscle structure every time he portrays a human figure. The answer is to study internal anatomy enough to have a good idea of the basics involved, then turn to the larger and simpler sectional patterns.

Practice and experience in drawing make the picture concept more definite in the mind and help to put it on paper.

1

2

The figure on the left is stockier and, in many instances, more typical. The same figure is slenderized at right for purposes of fashion and illustration.

It is hard to beat the trapezoid method of torso building for the beginner when the figure is mostly front or back view. But one must think ribcage as the upper trapezoid is set down and think pelvic bone when the lower one is added.

Below is a sketch drawn by fitting in the various components by means of overlapping.

3

A

B

C

At left is a side view with partial foreshortening. Think of the chest and hips as solid blocks. Notice the check points in each of the three sketches.

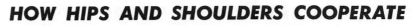

HOW HIPS AND SHOULDERS COOPERATE

It goes without saying that the two legs of a human being are his only means of standing support. Relieve one leg of its share of body weight and what happens? The other one takes on more of the load.

Even a weighted-down table with four legs will have a tendency to sag at one corner if that corner's leg is shortened or removed. Likewise, the hip-side of a human sags if he quits leaning on that side's leg and shifts his weight to the other leg. This shift forces the weight-bearing hip up as the other hip sags down.

Rather than the top part of the torso continuing to lean by going in the direction of the sloping hips, it swings back in order to compensate and maintain body balance. Hence, if a hip is forced up, the shoulder on that side comes down, for the chest bulk switches over on the opposite side of the center of gravity from the hip bulk. The flexible link of the mid-section accounts for their tilts being opposite.

There may be a few (rare) instances when both the feet appear to be firmly planted on the ground (figure at left), and yet, owing to the chest and shoulders being forcibly shifted to one side, the center of balance (line from neck pit) is likewise shifted farther to one side. Now comes the exception to the rule (termed "unnatural stance"): the leg carrying most of the weight has a <u>low</u> hip above it.

Here are three different poses illustrating the top of page principle. See the weight-bearing leg (arrow) and the shoulder above it.

CHEST BULK SHIFT

HIP BULK SHIFT

CENTER OF GRAVITY

WEIGHT DISTRIBUTION

DOWN

SHIFT

UP

SHIFT

WEIGHT

CLOSER

FARTHER

CHEST CENTER

PELVIC CENTER

MOST OF WEIGHT

LEAST OF WEIGHT

THE BACK OF THE HUMAN FIGURE

TRAPEZIUS
SPINE OF 7TH CERVICAL VERTEBRA
TENDINOUS AREA OF TRAPEZIUS

STERNO-MASTOID
SPINE OF SCAPULA
DELTOID

INFRA-SPINATUS
TRAPEZIUS
RHOMBOIDS
TERES MAJOR
TRICEPS, OUTER HEAD
TRICEPS, LONG HEAD
TRICEPS TENDON
TRICEPS, INNER HEAD
LATISSIMUS DORSI
LUMBAR APONEUROSIS
EXTERNAL OBLIQUE
ILIAC CREST
POSTERIOR SUPERIOR ILIAC SPINE
GLUTEUS MEDIUS
POSTERIOR SURFACE OF SACRUM
GLUTEUS MAXIMUS

TRO-CHANTER OF FEMUR
GLUTEUS MAXIMUS
ADDUCTOR MAGNUS
SEMI-TENDIN-OSUS
BICEPS CRURIS
VASTUS EXTERNUS
ILIO-TIBIAL BAND

Above left -- with arms at side the inside borders of scapulas (a) often line up with sides of hips (b). In some cases these borders are parallel in this body position. Notice in this drawing how the back is divided in thirds across by these shoulder blade edges. The borders or edges separate as the shoulders go forward, get closer as shoulders are pulled back. Directly to the left observe scapula prominence when hands are behind back. Spine here is subcutaneous; whereas, above right it is more imbedded.

Practice simplified back sketches such as those on right. See how center groove line of spine changes direction at midsection. Traces of scapula may be emphasized. See how trapezius flows into neck. (For related study: pp. 66, 71 ff. on neck and shoulders)

62

THE BACK AND THE FRONT RELATED

At left the pattern of back muscles is expressed in shaded differences. "a" is the tendinous area attached to the spine for the trapezius, and "b" is the tendinous area for the latissimus dorsi. These sinewy sheets have a tendency to depress when their muscles contract in relief.

TRAPEZIUS
DELTOID
INFRASPINATUS
TERES MAJOR
LATISSIMUS DORSI
GLUTEUS MEDIUS
GLUTEUS MAXIMUS

TRAPEZIUS

LATISSIMUS DORSI
SERRATUS MAGNUS
EXTERNAL OBLIQUE

Below is a diagram with the arm cut away showing the back muscles as they merge with the side and front muscles of the torso.

BONE LINE
BONE LINE
MUSCLE LINE

These dotted lines are likely to show on surface

MUSCLE LINE
BONE LINE
MUSCLE LINE

STERNO-MASTOID
TRAPEZIUS
DELTOID
INFRA SPINATUS
TERES MAJOR
PECTORALIS MAJOR
LATISSIMUS DORSI
SERRATUS MAGNUS
EXTERNAL OBLIQUE
RECTUS ABDOMINUS
ANTERIOR CREST OF ILIAC
GLUTEUS MEDIUS
GLUTEUS MAXIMUS
TENSOR FASCIAE LATAE
TROCHANTER MAJOR

GLUTEUS MAXIMUS
GLUTEUS MEDIUS
ILIO-TIBIAL BAND

Inner indentation of thigh's edge is higher

Inner indentation of knee's edge is lower

Inner portion of calf muscle is lower

Remember inner ankle bone is higher

At left are helpful facts about surface forms which every figure artist should know.

At right is a sketch of a well developed back with the muscles in a state of contraction.

PENCIL HANDLING IN FIGURE SKETCHING

Figure 1 is done in definite strokes of varied width after a very light concept of the entire figure has been set down.

In a composition with the appendages pulled in always be aware of the overall shape into which the figure fits — in this case a triangle.

1

2

Sketch No. 2 is an example of the light touch with the pencil roving over the paper. Hold the pencil loosely. Give free rein to your wrist and forearm.

In figure 3 the multiple line is used. Be sure to keep the strokes light and pliable. Think of the various sections in relation to the whole.

In No. 4 the first stage is done in more-or-less singular lines. After the proportions are correct, lightly block in where the shadow areas are to go. Seek to model the surface by laying down the strokes to conform with the particular shape beneath.

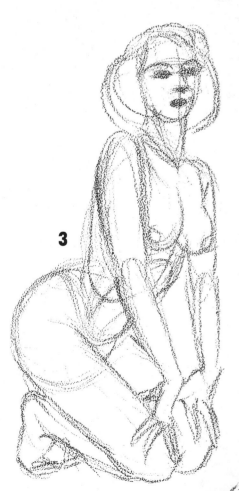

3

4

NOTES ON THE NECK

For the beginner it will be well to keep these facts in mind concerning the shape of the neck:

WRONG

1 The neck side view is very seldom straight up and down.

3 The lines of the neck side view do not end parallel to the ground. Nor are these side view lines the same length.

5 The sides of the front view neck do not grow abruptly out of a flat shoulder line.

7 The sides of the neck are rarely parallel for any distance at all.

RIGHT

2 The natural position is for the neck to tilt forward as it leaves the shoulders. This angle is usually more pronounced in a woman than a man.

4 The extremities of these lines end higher in the back and lower in the front. Also the back of the neck is shorter than the front line.

6 There are always varying degrees of a trapezoid at the base of the neck (front).

8 **9** The lines taper according to the individual shape and set of the neck muscles.

MAJOR NECK MUSCLES

10 FEMALE muscles are usually more graceful

Sterno-mastoid

Trapezius

Clavicle

Sternum

The two muscles that have to do with the appearance of the neck more than the others are the sterno-mastoid and the trapezius.

The secondary group in the Adam's apple area is mostly concealed. This portion of the female neck projects slightly in a rounded form.

MALE muscles may have more bulk

12

11 Mastoid bone

The "inner root" of the sterno-mastoid muscle shows less often — it may appear when neck is turned sharply or under conditions of strain.

Clavicle or collar bone

In the male the voice-box ridge sticks out above the pit of the neck which goes in.

The slashing angle of the sterno-mastoid gives the male neck a feel of power.

13

Sterno-mastoid

Trapezius

Attachment to spine of scapula

Base of skull

NECK TIPS

Sterno-mastoid

Trapezius

1 In the average neck the shortest distance across is where the sterno-mastoid seems to disappear on the other side of the trapezius.

2 The top seven cervical vertebrae constitute the neck. Here the trapezius and sterno-mastoid have been set to one side. Simply fit the letters one over the other.

3 In a highly developed male neck the shortest distance across may be a little below the ears. The sterno-mastoid swells at its center.

4 When the body is erect there is a:

slight hollow here

protrusion here (around seventh cervical vertebra)

hollow ridge here

5 When the body is bent forward (chin down and back curved) the reverse is true, except for the seventh vertebra.

Muscle protrusion

7th vertebra (high point along spine)

Spine showing

6 From the rear, top of trapezius may look like part of the back. From the front, same muscle looks like part of the neck.

7 The top six cervical vertebrae are well encased inside neck. The seventh (bottom of neck area) sticks out.

7th

7th

7th

8 Slight concave curve above seventh vertebra when head is turned toward shoulder and forward.

Flat line before rounding into spine

7th

9 When head is turned toward shoulder, sterno-mastoid of neck twists into trapezius. The inevitable result—wrinkles in the skin.

7th

EXPLAINING AND DRAWING NECKS

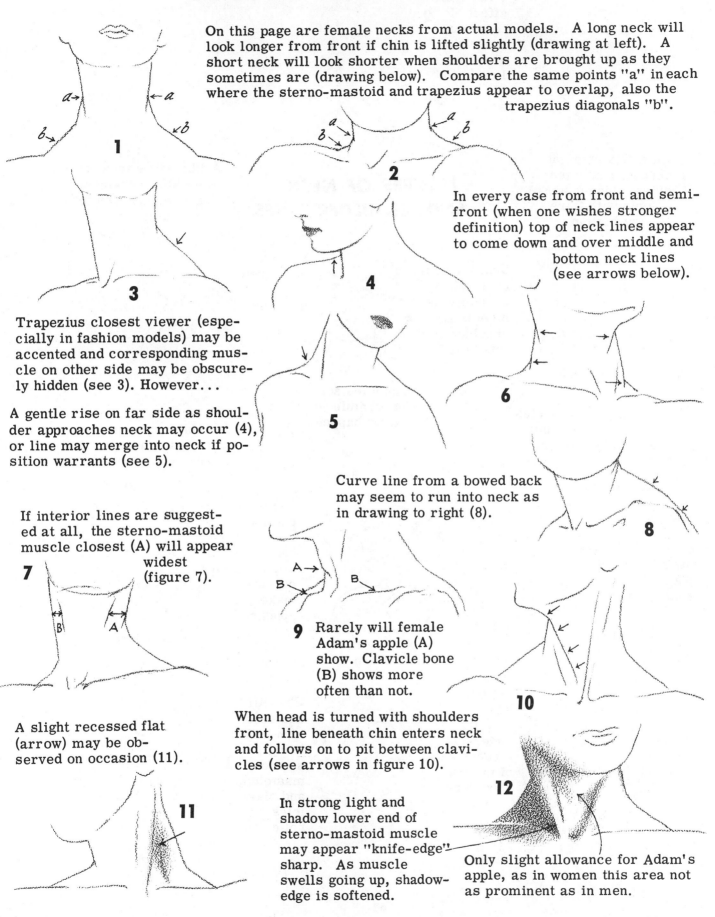

On this page are female necks from actual models. A long neck will look longer from front if chin is lifted slightly (drawing at left). A short neck will look shorter when shoulders are brought up as they sometimes are (drawing below). Compare the same points "a" in each where the sterno-mastoid and trapezius appear to overlap, also the trapezius diagonals "b".

1

2

3

In every case from front and semi-front (when one wishes stronger definition) top of neck lines appear to come down and over middle and bottom neck lines (see arrows below).

Trapezius closest viewer (especially in fashion models) may be accented and corresponding muscle on other side may be obscurely hidden (see 3). However...

A gentle rise on far side as shoulder approaches neck may occur (4), or line may merge into neck if position warrants (see 5).

4

5

6

Curve line from a bowed back may seem to run into neck as in drawing to right (8).

8

If interior lines are suggested at all, the sterno-mastoid muscle closest (A) will appear widest (figure 7).

7

9 Rarely will female Adam's apple (A) show. Clavicle bone (B) shows more often than not.

10

A slight recessed flat (arrow) may be observed on occasion (11).

When head is turned with shoulders front, line beneath chin enters neck and follows on to pit between clavicles (see arrows in figure 10).

11

12

In strong light and shadow lower end of sterno-mastoid muscle may appear "knife-edge" sharp. As muscle swells going up, shadow-edge is softened.

Only slight allowance for Adam's apple, as in women this area not as prominent as in men.

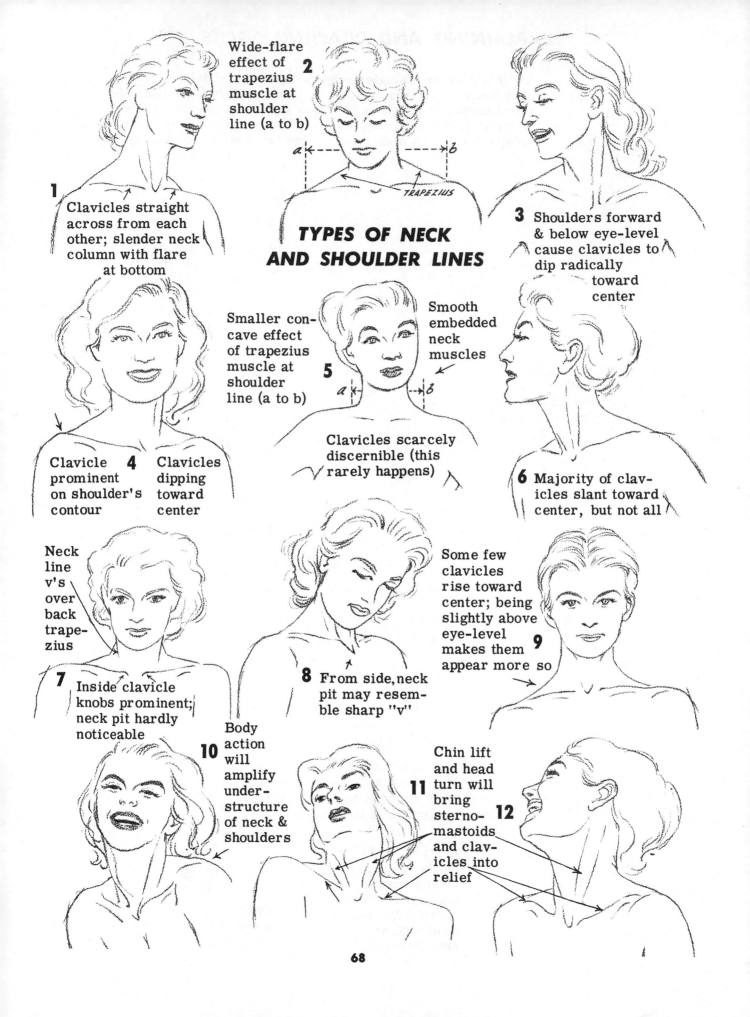

1 Clavicles straight across from each other; slender neck column with flare at bottom

2 Wide-flare effect of trapezius muscle at shoulder line (a to b)

a → ← *b*

TRAPEZIUS

TYPES OF NECK AND SHOULDER LINES

3 Shoulders forward & below eye-level cause clavicles to dip radically toward center

4 Clavicle prominent on shoulder's contour Clavicles dipping toward center

5 Smaller con-cave effect of trapezius muscle at shoulder line (a to b)

Smooth embedded neck muscles

a ← → *b*

Clavicles scarcely discernible (this rarely happens)

6 Majority of clav-icles slant toward center, but not all

7 Neck line v's over back trapezius

Inside clavicle knobs prominent; neck pit hardly noticeable

8 From side, neck pit may resem-ble sharp "v"

9 Some few clavicles rise toward center; being slightly above eye-level makes them appear more so

10 Body action will amplify under-structure of neck & shoulders

11 Chin lift and head turn will bring sterno-mastoids and clav-icles into relief

12

WHAT TO REMEMBER
IN DRAWING SHOULDERS

One of the biggest helps in drawing shoulders front view is the knowledge of the trapezoid shape (see dotted lines in diagram at right). Shoulders are not straight across from end to end. The trapezoid shape is always there, though it may vary greatly in length and height in different people. The sides of the trapezoid which slant up and toward each other may be concave or straight, and in some instances may be convex.

The slanting sides of the trapezoid are simply the tops of the trapezius muscles coming over the shoulder and inserting into the clavicle as indicated in drawing at right. The "X" markings show where the indentions and hollows are as they appear in the surface anatomy in the next drawing.

When one examines the exterior of the shoulders he can see evidence of the bone and muscle structure beneath. Take note of the heavy deltoid as this arm-raising muscle rounds over the head of the humerus or upper arm bone. The sternomastoids are two of the most showy muscles in the body. Find the ever-present trapezoid shape!

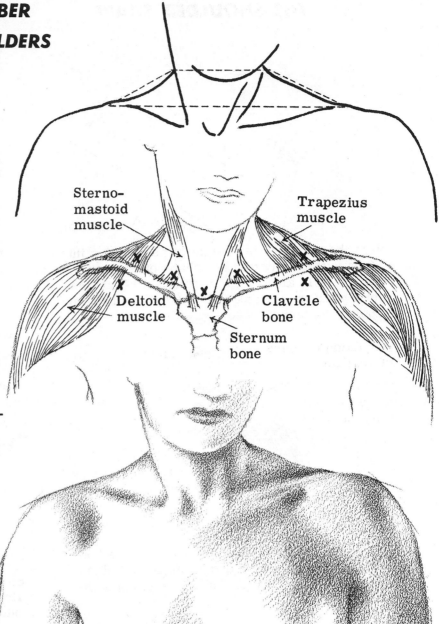

Sterno-mastoid muscle

Trapezius muscle

Deltoid muscle

Clavicle bone

Sternum bone

THE SHOULDERS SIMPLIFIED

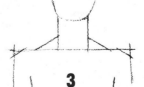

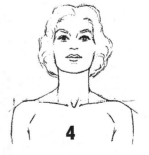

1 Shoulders are usually about four times as wide as the neck. On a sketch line (a) place a square (b) with the chin dropping over onto it.

2 Locate and sketch the trapezoid shape at the base of the neck. The top (dotted line) need not be drawn.

3 Cut off shoulder corners for tops of deltoid muscles. Locate armpits beneath the between point of the short oblique lines on either side of neck.

4 Neck pit will be slightly below original starting line. Clavicle lines on either side will slope down to it. Brief oblique lines above armpits suggest shoulder hollows.

THE SHOULDER SHAPE

1

Too often the shoulder is thought of as merging into the chest area without any distinct shape of its own. From the front there is always a thrusting out regardless of the arm's position. Think of the very top of the arm as overlapping the upper torso — a on top of b.

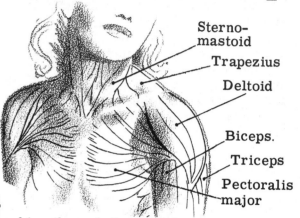

2

Keep in mind that c is the only point of the shoulder girdle that is fixed; that is, the clavicles at the sternum are held by ligaments. Points a & b may move several inches with c stationary. As the shoulder is raised and brought in, point a appears to overlap the outer extremity of clavicle b.

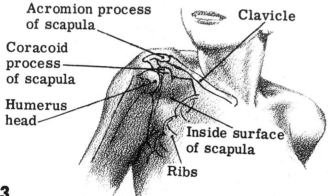

Acromion process of scapula
Coracoid process of scapula
Humerus head
Clavicle
Inside surface of scapula
Ribs

3

"X-raying" the surface anatomy one sees the bone framework which, enshrouded by muscle, holds out the shape under study. Take note of opposite shoulder also.

Sterno-mastoid
Trapezius
Deltoid
Biceps.
Triceps
Pectoralis major

4

Looking through the exterior we see how the muscles cover the shoulder joint. The deltoid attaches to the outer third of the clavicle and comes down over the pectoral (see black line). It is along here that the valley indention is the deepest between shoulder and chest. This shows on people.

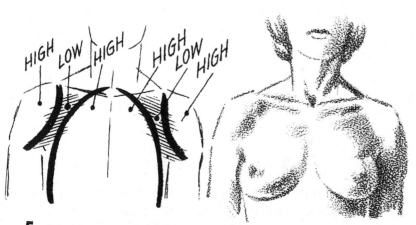

HIGH LOW HIGH HIGH LOW HIGH

5 Above observe the low in the surface anatomy between the highs of the shoulder joint and the rib-cage region. Often a shadow is cast in this low.

6

Here is a contrivance which may help in depicting dimension through the shoulders. It is the "fan" or arc of hollows: the two outside ones are more prominent; the three inside ones may be less prominent. On some people particular ones show more than others.

1

2

3 **4**

When hand is laid on shoulder in above position, an arc skirting bottom of shoulder-blade (or scapula) will likewise touch bottom of deltoid (big shoulder muscle) and cross wrist. Notice how dotted line off finger tips encircles shoulder. Also, wrist is approximately half way between elbow and back of shoulder.

Refer to shoulder-blade protruding from back in figure 2. Follow same arc as in figure 1. In 3 examine simplified scapula that causes this protrusion (for more detailed information on this bone see fig. 6 below). In 4 observe deltoid muscle rounded over bones which makes evident indention on arm at arc's crossing.

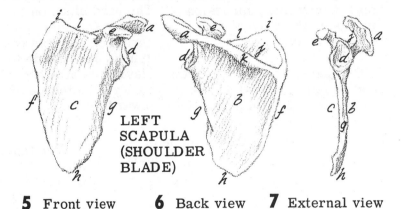

LEFT SCAPULA (SHOULDER BLADE)

5 Front view **6** Back view **7** External view

a. Acromion process
b. Infra-spinous fossa
c. Anterior or ventral surface
d. Glenoid cavity (for head of humerus)
e. Coracoid process
f. Interior or verte-

bral border
g. External or axillary border
h. Inferior angle
i. Medial angle
j. Supra-spinous fossa
k. Spine
l. Superior border

Right: Simplified rough of shoulder blades...

f shows prominently

a & k next in prominence

h shows on occasion

i seldom shows

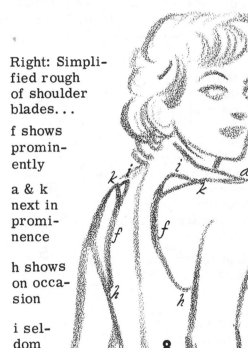

8

Sketch No. 9 gives position of scapula in relation to rib cage, back bone and humerus (upper arm bone). Direct rear view.

9

In figure 10 observe how scapular under-structure forms base for join of arm (view slightly foreshortened). Notice how bottom of area seems to curve under arm into lower line of breast.

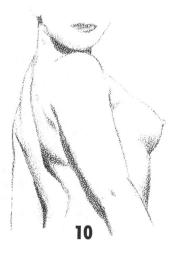

10

EXPLAINING THE SHOULDER'S APPEARANCE

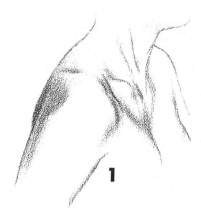

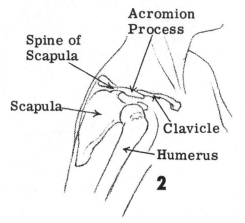

Acromion
Process

Spine of
Scapula

Scapula

Clavicle

Humerus

1

2

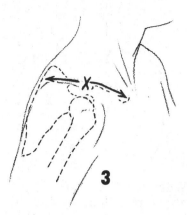

3

1. See how the outer surfaces betray the framework beneath. These projections are important for they find expression through clothing even when it is loosely fitted.

2. Compare the exterior in the first illustration with the bone arrangement shown here. Note the spine of the shoulder-blade (scapula) as well as the internal border of that very evident bone. The hard place on the top outside of your shoulder (feel it) is the acromion process of that narrow spine. Just inside this point the clavicle is attached and assumes showy prominence as it travels inward.

3. From this outer juncture (marked X) the spine of the scapula and the clavicle recede on either side. At the point of each arrow above, the two bones become rather conspicuous. Movement of the arm causes them to become more distinctly outlined. Observe people's shoulders!

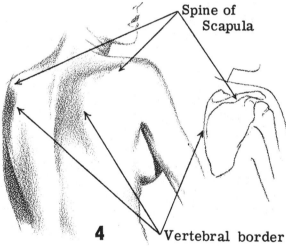

Spine of
Scapula

Vertebral border

4

4. The top arrows at the left all point to the spine that juts out on the scapula. This marks the turning place which divides the "back" from the shoulders. The bottom arrows point to border of this blade-bone which is nearest the central vertebra. They separtate more as the shoulders are brought forward.

5. On the right look at the two knobs of the clavicles protruding at the neck's base.

5

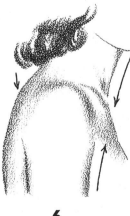

6 & 7. When one is looking directly into the shoulders from the side, here is an item which is helpful to remember: the lines of the upper arm where they join the shoulder spread outward slightly. The front line points into the slope of the neck. The arm must be hanging naturally by the side and the neck and head in their relaxed position. In like manner the outside line of the arm points to the scapula spine's origin on the scapula. This, as mentioned in the foregoing notes, is often a marked bulge in the back contour. Also observe that distances "a" and "b" are usually the same (between the black dots: neck's length and space from neck's base to where arm line begins).

Models in 6 & 7 are different to illustrate consistency of these features.

6

7

MAKING THE SHOULDERS LOOK RIGHT

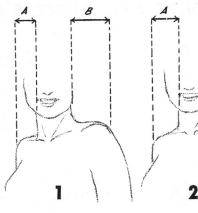

1

2

3

The three diagrams at the right show why the artist should allow more width for the distant shoulder and less width for the nearest shoulder in drawing the semi-front view.

By simple laws of perspective one would expect distance B to be wider than A. Such is not usually the case except when shoulders are reared back in an unnatural position.

Nor is it right to make A and B same distance as in above diagram. If subject is standing at attention or forcibly setting the shoulders, then such an alignment might occur.

Because shoulder girdle when relaxed has a tendency to bow in slightly, shoulder A curls around, whereas viewer is looking head on into shoulder B. Hence distance A is greater than B.

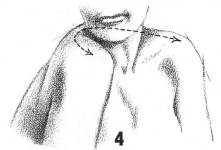

4

Either side of the shoulder girdle is quite flexible. The extent to which the shoulder tops may be turned in is demonstrated in the above sketch.

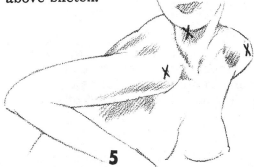

5

When elbows are raised and shoulders are thrust forward, chin may be pulled back, making center root of neck (middle X) well behind shoulder points.

6

Even in side view shoulders are often set forward to reveal part of back (see flat of shoulder blade at bracket).

7

Above and below the arrows point to the ridge of the "roof" of the shoulders (top of trapezius muscle).

At lower left is top view of shoulder girdle's bone structure. Only attachment is at sternum bone which gives girdle much freedom. Shoulders may be brought forward from breast center as dotted lines indicate.

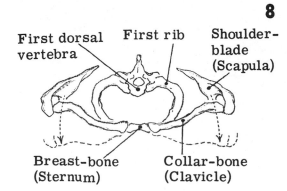

8

First dorsal vertebra
First rib
Shoulder-blade (Scapula)
Breast-bone (Sternum)
Collar-bone (Clavicle)

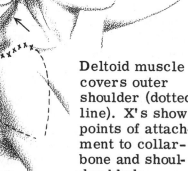

9

Deltoid muscle covers outer shoulder (dotted line). X's show points of attachment to collar-bone and shoulder blade.

THE BONES AND MUSCLES OF THE ARM

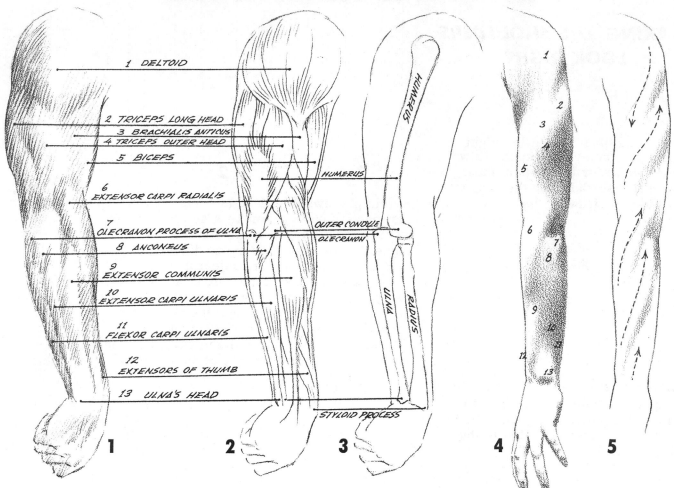

1 DELTOID
2 TRICEPS LONG HEAD
3 BRACHIALIS ANTICUS
4 TRICEPS OUTER HEAD
5 BICEPS
6 EXTENSOR CARPI RADIALIS
7 OLECRANON PROCESS OF ULNA
8 ANCONEUS
9 EXTENSOR COMMUNIS
10 EXTENSOR CARPI ULNARIS
11 FLEXOR CARPI ULNARIS
12 EXTENSORS OF THUMB
13 ULNA'S HEAD

HUMERUS
OUTER CONDYLE
OLECRANON
ULNA
RADIUS
STYLOID PROCESS

1 2 3 4 5

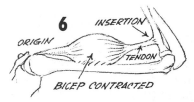

6
ORIGIN
INSERTION
TENDON
BICEP CONTRACTED

Above left is an outside view of the right arm. See how the muscles underneath show on the surface. At right is a female left arm with corresponding numbers to muscles. Notice dotted lines representing muscle trend as they pass beneath each other.

Appendage muscles have two attachments: an origin, generally closest to spinal axis, and an insertion, where it grabs onto the bone to be pulled. When the muscle tissue at center is contracted, the insertion moves toward the origin. Tendons tie muscle to bone and take up less space.

Muscles work in opposing pairs. Flexors pull in; extensors extend or pull the other way. When one muscle becomes active, like a seesaw its opposite becomes passive in a cooperative manner.

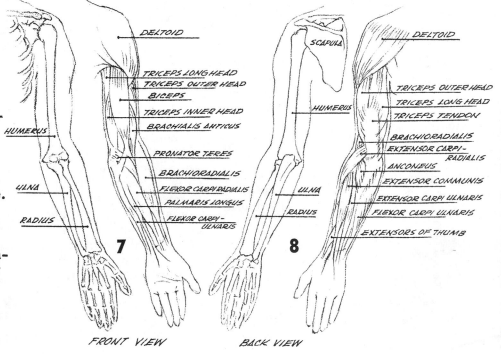

DELTOID
TRICEPS LONG HEAD
TRICEPS OUTER HEAD
BICEPS
TRICEPS INNER HEAD
BRACHIALIS ANTICUS
PRONATOR TERES
BRACHIORADIALIS
FLEXOR CARPI RADIALIS
PALMARIS LONGUS
FLEXOR CARPI-ULNARIS
HUMERUS
ULNA
RADIUS

SCAPULA
DELTOID
HUMERUS
TRICEPS OUTER HEAD
TRICEPS LONG HEAD
TRICEPS TENDON
BRACHIORADIALIS
EXTENSOR CARPI-RADIALIS
ANCONEUS
EXTENSOR COMMUNIS
EXTENSOR CARPI ULNARIS
FLEXOR CARPI ULNARIS
EXTENSORS OF THUMB
ULNA
RADIUS

7 FRONT VIEW 8 BACK VIEW

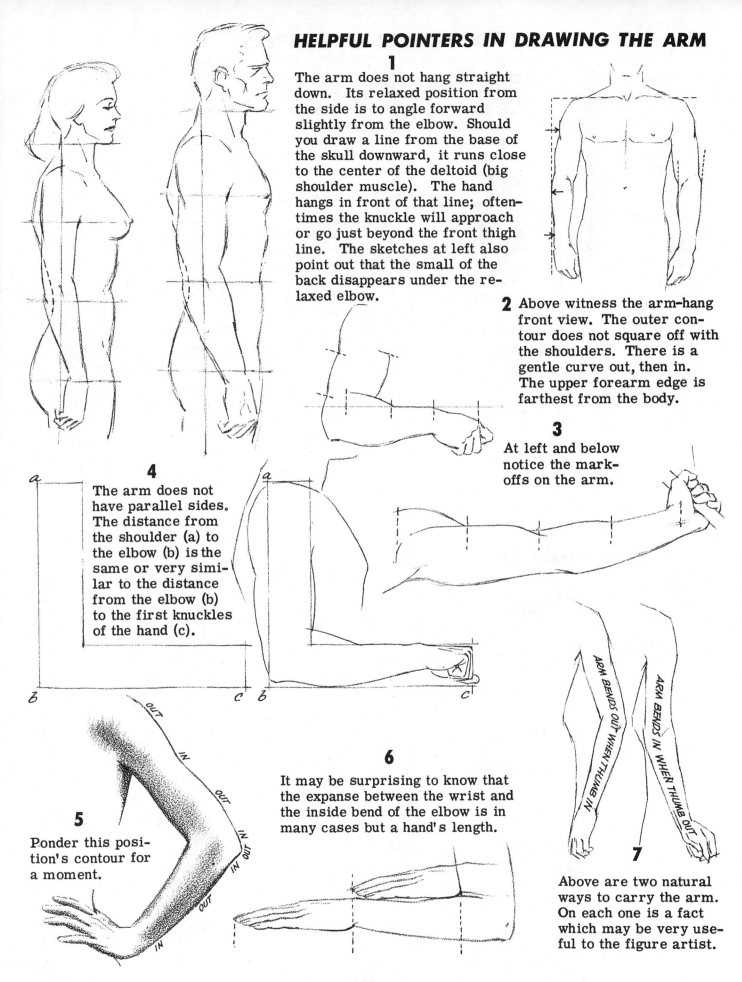

HELPFUL POINTERS IN DRAWING THE ARM

1

The arm does not hang straight down. Its relaxed position from the side is to angle forward slightly from the elbow. Should you draw a line from the base of the skull downward, it runs close to the center of the deltoid (big shoulder muscle). The hand hangs in front of that line; oftentimes the knuckle will approach or go just beyond the front thigh line. The sketches at left also point out that the small of the back disappears under the relaxed elbow.

2 Above witness the arm-hang front view. The outer contour does not square off with the shoulders. There is a gentle curve out, then in. The upper forearm edge is farthest from the body.

3
At left and below notice the mark-offs on the arm.

4
The arm does not have parallel sides. The distance from the shoulder (a) to the elbow (b) is the same or very similar to the distance from the elbow (b) to the first knuckles of the hand (c).

5
Ponder this position's contour for a moment.

OUT
IN
OUT
IN
OUT
IN
OUT
IN
IN OUT
IN

6
It may be surprising to know that the expanse between the wrist and the inside bend of the elbow is in many cases but a hand's length.

7

ARM BENDS OUT WHEN THUMB IN

ARM BENDS IN WHEN THUMB OUT

Above are two natural ways to carry the arm. On each one is a fact which may be very useful to the figure artist.

THE WAY THE ARM TAPERS

1 There are two tapers to the straightened arm. From the top to the elbow is one; the other from the elbow to the wrist. Especially is this true when the arm is turned so that you see across the prominences (condyles) of the lower humerus at the elbow.

2 The widest part of the arm below the deltoid is just below the elbow crease (between check marks at left). Across the widest part of the wrist is still narrower than narrowest part of upper arm (see dotted lines in arm at right).

3 Both arms on the left are slender types. Observe the varying widths across the elbows of the shorter & stockier person on the right. The left arm is a view through the condyles; the right elbow is across the condyles.

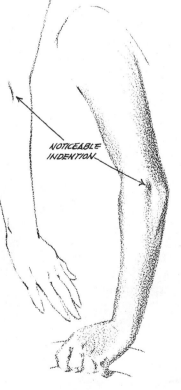

THE HUMP THAT TURNS TO A DIMPLE

4 Notice that the outer condyle (marked x on both arm and bone structure below) is fairly prominent when the elbow is bent.

5 As the arm is straightened this "x" point becomes an indention in the surface (see three arms at right).

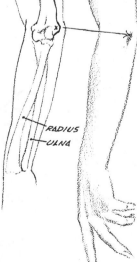

NOTICEABLE INDENTION

RADIUS
ULNA

HUMERUS

RADIUS ULNA

FACTS THAT MAKE ARM DRAWING EASIER

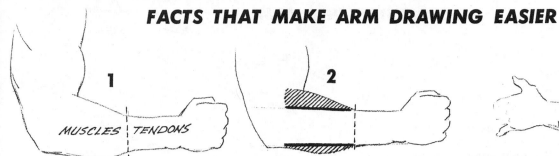

1 MUSCLES | TENDONS

2

3

It is helpful to know that the major forearm muscles merge into tendons about midway between the elbow and wrist. Should you extend the nearly parallel lines from the front half, the shaded area (fig. 2) would represent the extra width of the muscles in the back half. Tightening of muscles makes this particularly so.

Above is a characteristic mark that nearly always shows at the bottom of the outside forearm. It is sometimes called the "ulnar furrow" because the edge of the ulna bone may be traced close under the skin. Additionally, two muscles skirt this ulna edge, making the furrow more prominent.

Below is a female arm displaying the ulnar furrow. Directly below that is the same arm's bone structure.

5

6

7

4

HUMERUS
RADIUS
ULNA

The dotted line of fig. 6 locates the ulna's edge and the furrow between the extending and flexing muscle. See the external influence on the male arm (fig. 5) and female (fig. 7).

When the back of the hand is up and palm down, the radius crosses over the ulna. Trace the ulnar furrow; also, observe the gentle swell off the "tendon half" to the "muscle half" of the forearm.

8

HUMERUS
RADIUS
ULNA

9

RADIUS
ULNA

THE OUTSTRETCHED ARM

1
Too many students imagine the edges of the outstretched arm to be straighter than they are. The four top protrusions to look for and record are (above): 1. Wrist, 2. Noticeable forearm muscle widening, 3. Bicep and 4. Deltoid.

2 Notice how the bicep runs into the forearm (a) and the under line (b) from the elbow runs in the opposite direction into the upper arm.

RADIUS
ULNA
HUMERUS
INNER CONDYLE

3
In the two drawings above observe the marked influence of the inner condyle of the humerus. In most arm positions this is the most "showy" bone point of them all.

a

b

4
When the hand is pulled back (as above), the extensor muscles of the forearm which do it swell and rise (a) while the flexors (b) relax.

If entire arm is extended with <u>palm up</u>, then hand is turned completely over, leaving upper arm as is; straightened arm **5** will appear to bow down. This is even more true with female arm (see sketch at right).→

a b

c

d

6
Under great stress the long head (a) and the inner head (b) of the triceps will show beneath the inside arm; also, the tendon of the biceps (c) and the tendons of the flexor muscles (d).

HUMERUS
EXTERNAL CONDYLE
RADIUS
INTERNAL CONDYLE
ULNA

SUPINATOR LONGUS
EXTENSOR CARPI RADIALIS LONGUS
EXTENSOR CARPI RADIALIS BREVIS
ABDUCTOR POLLICIS LONGUS
EXTENSOR POLLICIS BREVIS

DELTOID
TRICEPS OUTER HEAD
TRICEPS LONG HEAD
BRACHIALIS ANTICUS
TRICEPS TENDON
TRICEPS INNER HEAD
EXTERNAL CONDYLE
ANCONEUS
OLECRANON OF ULNA
INTERNAL CONDYLE
ULNA
COMMON EXTENSOR OF THE FINGERS
EXTENSOR CARPI ULNARIS
FLEXOR CARPI ULNARIS

7 Coming off the external condyle and its ridge above (dotted) are the supinators and extensor muscles (on back of forearm) which turn the palm up and extend the fingers. Coming off the internal condyle are the pronator and flexor muscles which turn the palm down and flex (close) the fingers.

MORE TIPS ON DRAWING THE ARM

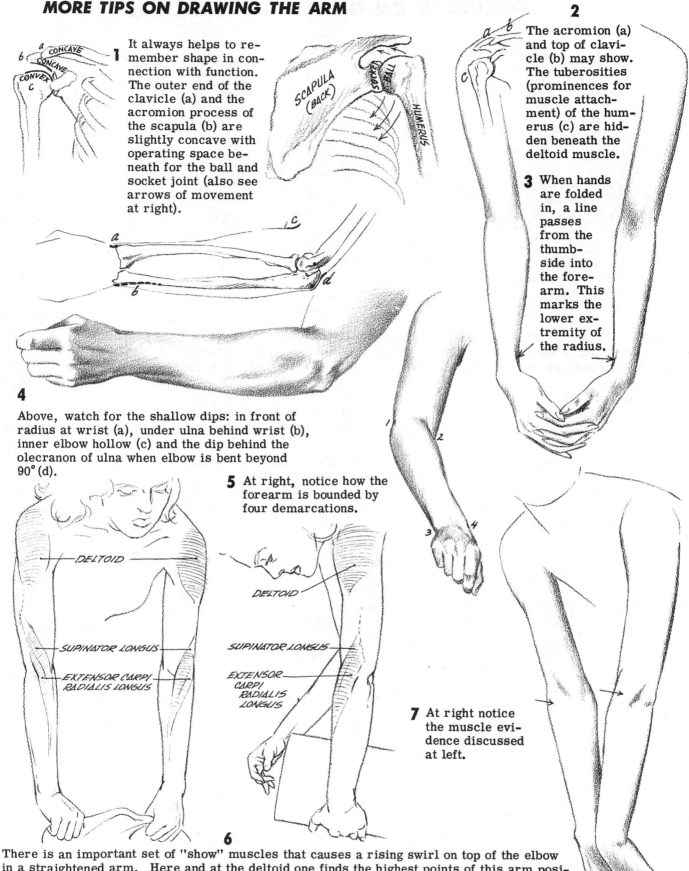

1 It always helps to remember shape in connection with function. The outer end of the clavicle (a) and the acromion process of the scapula (b) are slightly concave with operating space beneath for the ball and socket joint (also see arrows of movement at right).

2 The acromion (a) and top of clavicle (b) may show. The tuberosities (prominences for muscle attachment) of the humerus (c) are hidden beneath the deltoid muscle.

3 When hands are folded in, a line passes from the thumbside into the forearm. This marks the lower extremity of the radius.

4 Above, watch for the shallow dips: in front of radius at wrist (a), under ulna behind wrist (b), inner elbow hollow (c) and the dip behind the olecranon of ulna when elbow is bent beyond 90° (d).

5 At right, notice how the forearm is bounded by four demarcations.

7 At right notice the muscle evidence discussed at left.

6 There is an important set of "show" muscles that causes a rising swirl on top of the elbow in a straightened arm. Here and at the deltoid one finds the highest points of this arm position. Their sides leave a marked contrasting low which shows. (Straighten your own arm and feel these muscles with the other hand.) They come from behind, starting at the external condyloid ridge of the humerus and swirl up and over into forearm tendons. The extensor carpi radialis longus extends the wrist and the brachioradialis (supinator longus) supinates (or turns the palm up) and flexes the elbow.

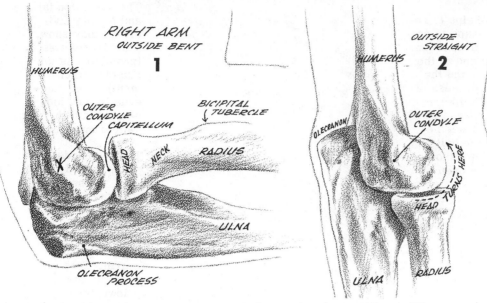

RIGHT ARM
OUTSIDE BENT
1

HUMERUS
OUTER CONDYLE
CAPITELLUM
BICIPITAL TUBERCLE
HEAD
NECK
RADIUS
X
ULNA
OLECRANON PROCESS

OUTSIDE STRAIGHT
2

HUMERUS
OLECRANON
OUTER CONDYLE
TURNS HERE
HEAD
ULNA
RADIUS

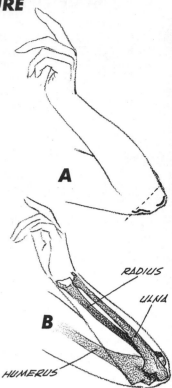

A

B
RADIUS
ULNA
HUMERUS

Above is the inside bone structure of the right elbow joint. There are three bony parts which show on the surface: the inner and outer prominences or condyles of the humerus and the bottom projection or olecranon of the ulna. The outer condyle (marked "x") is visible when the elbow is bent, but "turns" to a dimple on the surface when the arm is straight. At the elbow-end the ulna is heavy and locks into the humerus to form a hinge. The radius head is scarcely discernible outwardly, but it is well to know that this small, thick disc rotates every time the wrist turns, whereas the ulna keeps its place. In this wrist action the entire radius crosses over the ulna. The radius here is small; at the thumb-side of the wrist it is large. The reverse is true of the ulna. Here it is large; at the little finger-end of the wrist it is small. In a sense the radius "belongs" to the wrist, and the ulna "belongs" to the elbow.

In fig. A the three black lines are the bony parts of fig. B which may be seen on the surface. The dotted line runs through the condyles representing the directional axis out of which the ulna operates.

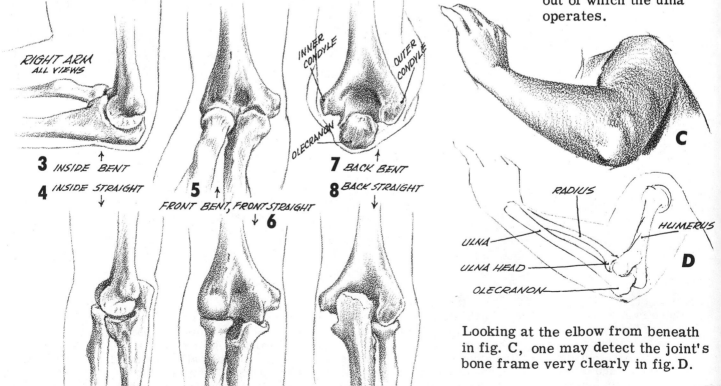

RIGHT ARM
ALL VIEWS

INNER CONDYLE
OUTER CONDYLE
OLECRANON

3 INSIDE BENT
4 INSIDE STRAIGHT
5 ↑
FRONT BENT, FRONT STRAIGHT
↓ 6
7 BACK BENT
8 BACK STRAIGHT

C

RADIUS
ULNA
ULNA HEAD
OLECRANON
HUMERUS
D

Looking at the elbow from beneath in fig. C, one may detect the joint's bone frame very clearly in fig. D.

MAKING THE ELBOW LOOK RIGHT

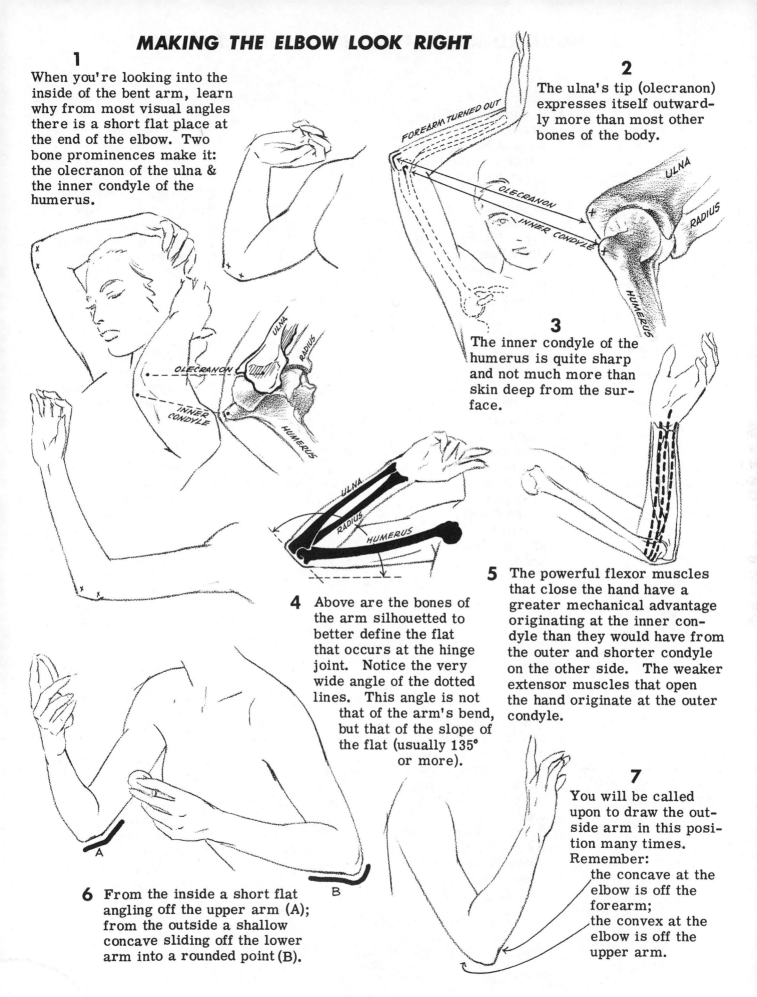

1 When you're looking into the inside of the bent arm, learn why from most visual angles there is a short flat place at the end of the elbow. Two bone prominences make it: the olecranon of the ulna & the inner condyle of the humerus.

2 The ulna's tip (olecranon) expresses itself outwardly more than most other bones of the body.

3 The inner condyle of the humerus is quite sharp and not much more than skin deep from the surface.

4 Above are the bones of the arm silhouetted to better define the flat that occurs at the hinge joint. Notice the very wide angle of the dotted lines. This angle is not that of the arm's bend, but that of the slope of the flat (usually 135° or more).

5 The powerful flexor muscles that close the hand have a greater mechanical advantage originating at the inner condyle than they would have from the outer and shorter condyle on the other side. The weaker extensor muscles that open the hand originate at the outer condyle.

6 From the inside a short flat angling off the upper arm (A); from the outside a shallow concave sliding off the lower arm into a rounded point (B).

7 You will be called upon to draw the outside arm in this position many times. Remember:
the concave at the elbow is off the forearm;
the convex at the elbow is off the upper arm.

A SIMPLIFIED APPROACH IN DRAWING THE HAND

1 A confinement line drawn completely around the palmar surface of the hand gives the appearance of a "flat-iron." It is the ideal shape for thrust or pushing. The mere outline of the human hand possesses much in the way of beauty of form.

2 By extending a line from the wrist we enclose the finger area. The hand's prized auxiliary, the thumb, curves cooperatively toward the fingers which would be lost without its assistance.

3 By means of a half-way line between the base of the hand and the uppermost tip, we will be able to gage the position of the fingers in relation to the thumb and the rest of the hand.

4 By drawing a curved line above this half-way mark, we will find the base-line of the fingers. The little finger base is the only one which falls below this straight line. Yet all the finger corners (black dots) come above this center line. Distances 1 through 5 may be called equal. Center finger goes to top of oval. Each finger tapers with oval.

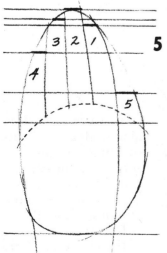

5 The length of the center finger is already determined. Fingers 1 and 3 may be the same, but often 3 is a bit longer. Four steps down, and the thumb 5 comes a little above the curved base-line of the four fingers.

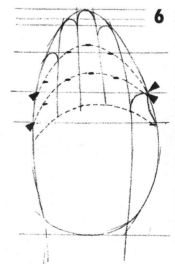

6 Round the finger tips. The thumb pulled in like this is in semi-side view. Finger joints likewise follow the curve as indicated. The top arc starts on the thumb line and ends on the thumb line. The middle·arc starts on the original center line and ends on the same thumb line. (See black triangles)

7 An interesting note concerning the base of the fingers: A short prominent skin-fold angles away from the inside fingers following the curved base-line upon which the fingers stand.

8 When the hand is flattened, as it is in these sketches, and the thumb is curved in, the palmar skin-fold at the big base of the thumb points to the thumb's top joint. Also there is a marked crease on the thumb which points to the bunched loose skin that may look like an inverted "T."

9a Add the two other more distinct fold lines in the palm as indicated. The pits between the fingers toward their base may be darkened as there is often a deeper "hole" there. An extra fold line at the wrist is always there and a suggestion of the tendons.

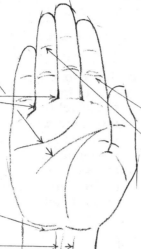

9b Having predetermined the skin-folds over the finger joints in diagram number 6, it is well to know that on a hand this large or larger you may record a double line on the first row of joints. Usually a single line will suffice on the top set. In drawing a small hand a fragment of a single line will be sufficient on the first row also. Or in a very small hand you may leave them out entirely.

10 From the back side of the hand the fingers will appear to be longer. The division lines will reach the lower dots.

11 Turning the flattened hand over you will observe that part of the inside thumb will be cut off from view. Too, you will see loose skin-folds on all the knuckles. The folds on the fingers will be enclosed in small circular formations. The top row will be less prominent. The protrusions of the bottom knuckles will be elliptical and shadows or skin-folds will take this shape. The narrow hand bones and tendons are in evidence here.

12 The finger-nails come down about halfway to the top joints. There are short drag lines falling away from the center finger position at the base of the fingers. There may be tendon suggestions as these thin muscles fan from the center of the wrist to each of the fingers. You may record the wrist bone and a hollow beneath the thumb. The wrist is closer to you than the hand, and in a sense is on top.

THE HAND — SIDE VIEW SIMPLIFIED

1 The straightened hand from the side represents, in its simplest form, a tapering trapezoid. From the outside or little finger side the base of the trapezoid will be thicker than from the thumb side (compare with diagram at right).

Notice the very evident step-down from the wrist to the hand. There is always a change of direction at this point.

2 A smaller trapezoid shape is in evidence running from the wrist to the base of the little finger. Its length is half the distance of the entire hand.

3 By establishing a rectangle over the hand, some facts of proportion may be learned. The center point (black dot) falls on the back of the hand and gives us the hand thickness there. Where the heel of the hand joins the wrist, and also the width of the finger, may be determined by striking the quarter mark from the bottom.

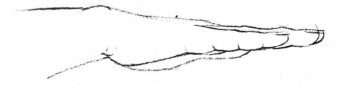

4 The finished side-view has all the modern lines of a high-speed rocket.

5 From the inside or thumb side the trapezoid shape has a more noticeable step-down where the heel of the hand meets the under-side of the wrist.

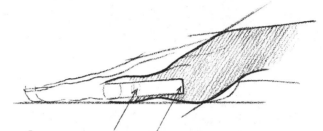

6 The two knuckle-bones of the thumb are in tandem with the thumb-nail, and the knuckle part that shows is about the same width as the nail itself. The shaded area demonstrates the decided step-down and change of direction from the wrist to the thumb. The ball-base of the thumb is the most powerful part of the hand.

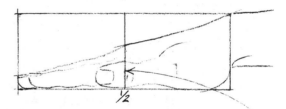

7 Owing to the greater drop of the thumb-base, a superimposed rectangle covering the inside of the hand will be wider than the rectangle at the left. The half-way line crosses the top knuckle of the thumb.

8 The thumb laid alongside the hand will cause a contraction of the thumb base, hence the elliptical shape there.

BONES OF THE HAND

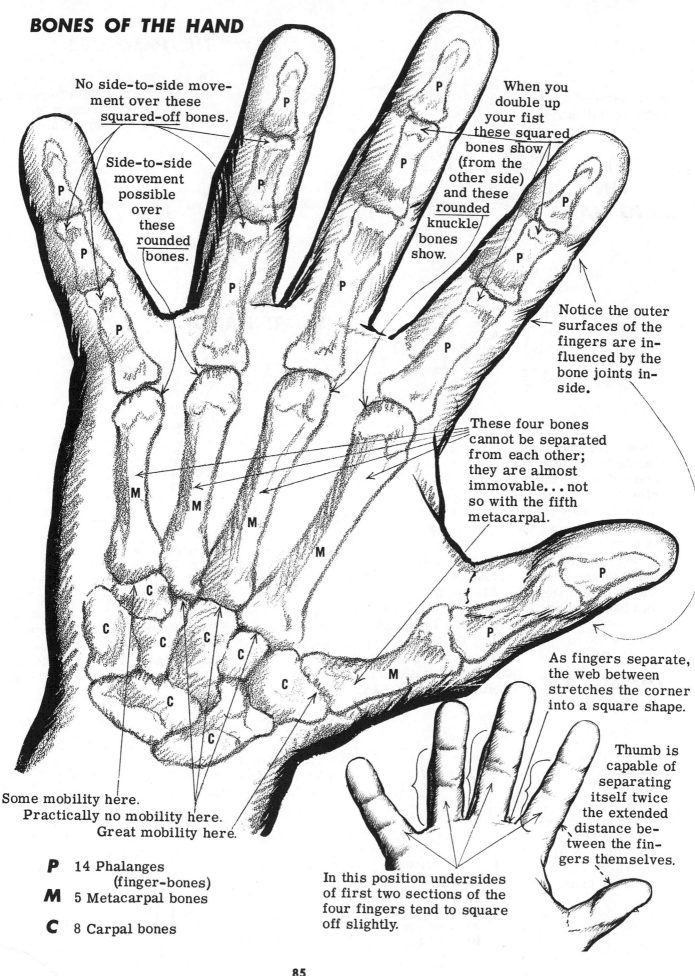

No side-to-side movement over these squared-off bones.

Side-to-side movement possible over these rounded bones.

When you double up your fist these squared bones show (from the other side) and these rounded knuckle bones show.

Notice the outer surfaces of the fingers are influenced by the bone joints inside.

These four bones cannot be separated from each other; they are almost immovable... not so with the fifth metacarpal.

Some mobility here.
Practically no mobility here.
Great mobility here.

As fingers separate, the web between stretches the corner into a square shape.

Thumb is capable of separating itself twice the extended distance between the fingers themselves.

In this position undersides of first two sections of the four fingers tend to square off slightly.

P 14 Phalanges (finger-bones)

M 5 Metacarpal bones

C 8 Carpal bones

The two hands on this page have been drawn with fingers set apart to better show the actual shape of the palm surface.

One reason middle finger is tall is its starting position.

1
THE
LONG HAND

Notice tendency of fingers to bow in. If dotted lines were continued they would meet.

D

C

a

B

A

2
THE
SHORT HAND

4

3

2

1

There are four major flesh pads inside the hand. The most prominent contains the versatile muscles of the thumb (A). The pad directly under the knuckles of the hand (D -- across the dotted line) is next in prominence. The two inside pads (B and C) are the flattest and are somewhat lost as A and D come together. Flex your own hand and see.

Little "a" is the only loose-skin area on the inside of the hand. This is the crumpled web between the thumb and index finger. It plays prominently in appearance on either side of the hand.

The conspicious creases inside the hand are lines numbered 1, 2 and 4. The line marked 3 may or may not appear (like other minor creases), but it is included here to make the big "M"-- a device to remember. Notice how the center of the wrist points to crease 1 and how the top of the M frames the root of the index finger.

3
THE SQUARE

X

This is a square superimposed over the long palm. Notice where contour lines cross over.

Protrusions of finger-bones fit into indentions. (Back of hand -- bones brought together)

4
THE ARCH

Straighten your own fingers and bring them together so they are side-by-side. They fit because all the knuckles of the finger-bones are staggered in position. Their "arched" position helps to stagger them.

X

The short palm compared with a square. The chief difference between the two is in the top areas marked "x".

SKIN FOLDS ON THE FINGERS SIMPLIFIED

Notice lines separating pads on inside of fingers run about half way around fingers. This is true of fingers in any position. These fold lines are accented more as fingers are bent. Examine your own fingers.

See these fingers in hand "A"

Small part of skin "telescopes" into fold.

Double line may show in secondary stage.

You may not draw them in a straightened finger but a trace of the line is still there.

In the straight finger (side view) skin fold lines from the joints come a little way around finger. They do not meet with the underneath line. There is a narrow area between devoid of lines.

These skin fold lines are of important help in depicting the foreshortened fingers. Think of each section of finger as a cylinder fitted onto another cylinder or "tin can." The skin fold becomes a partial rim of the can.

Compare diagrams with hands A through D.

THE WRITING HAND

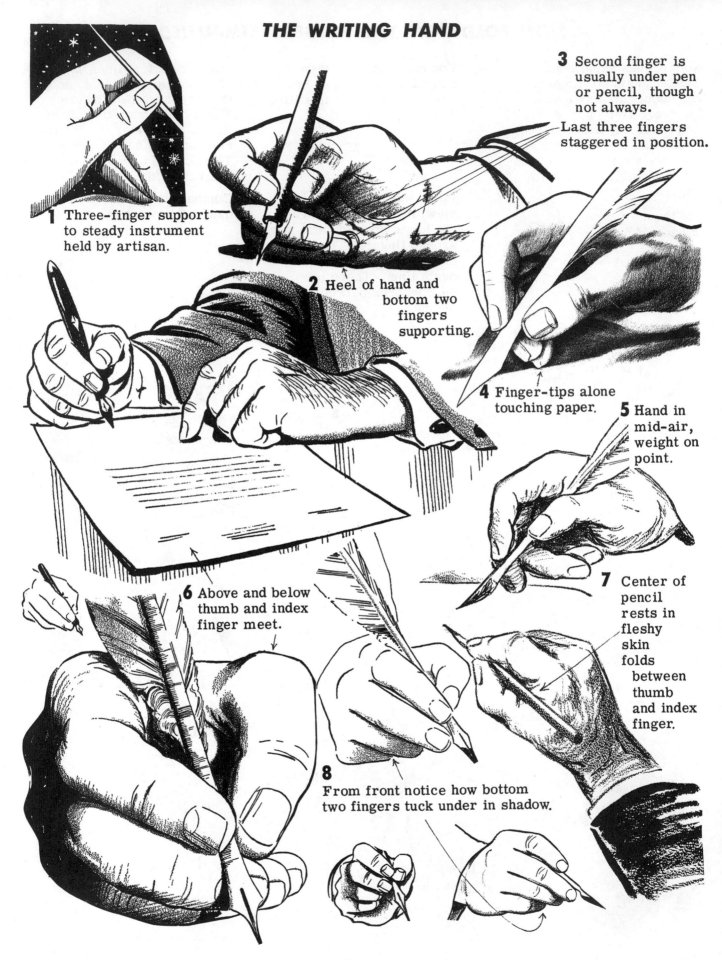

1 Three-finger support to steady instrument held by artisan.

2 Heel of hand and bottom two fingers supporting.

3 Second finger is usually under pen or pencil, though not always.

Last three fingers staggered in position.

4 Finger-tips alone touching paper.

5 Hand in mid-air, weight on point.

6 Above and below thumb and index finger meet.

7 Center of pencil rests in fleshy skin folds between thumb and index finger.

8 From front notice how bottom two fingers tuck under in shadow.

THE FIST

1 Drawing the clenched fist calls for expressing extreme tension on the part of the hidden tendons inside the hand as well as tightly stretched skin outside the hand.

2 Knuckles on back of hand are more rounded; whereas, knuckles of fingers have a tendency to square off.

3 Thumb does its best to double up too. The tighter the clinch the more nearly thumb takes on squared position. Notice multiple folds inside.

4 The index finger always sticks out farther than the others, followed by the middle finger. Reason: Fleshy base of thumb is pulled in and gets in the way.

5 Back of the hand is smoothest in clinch. These tendons and veins are compressed.

6 Object in hand tends to line up fingers more evenly.

7 In the fist there is always foreshortening somewhere.

8 Web between fingers is taut... lines always point up toward thumb-side of hand.

9 Extremity of thumb is laid alongside first two fingers.

PRACTICE THE "ROUGH"

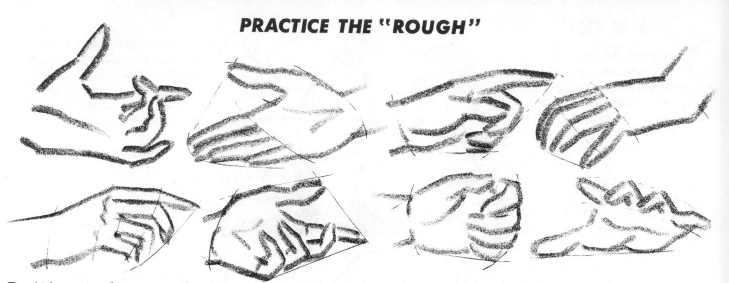

Don't become discouraged in the matter of drawing hands. No artist has ever lived who could draw the human hand in all given positions without some struggle. You are very close to a model — at the end of your arm. Use a mirror occasionally. Examine pictures of hands. Think in terms of the interior, the wrist and the fingers. At times it helps to imagine the overall hand within confinement lines.

THE OPEN HAND

A. In drawing the open hand take into consideration that it requires conscious effort to straighten one's hand. Even so, the fingers usually do not appear mathematically parallel. See how the finger tips flatten slightly just before getting to the rounded end. B. Here the little finger is the "lonesome" finger (by itself). C. In this case it is the index finger. Often the fingers align themselves in this manner — such adds interest to the hands.

METHODS IN DRAWING THE LEG

Here are several exercises suggested as helps in understanding leg construction.

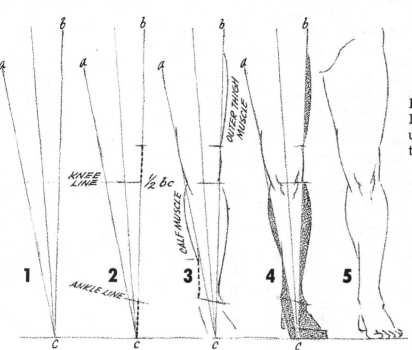

The natural stance of a man is not with his heels together but with his feet some inches apart. If a line is drawn from the outside top of the thigh (b) perpendicular to the floor, the contact point (c) may be the ball of the foot just behind the big toe which takes much of the body weight. Next draw an oblique line from point "c" to the crotch (a). This beginning will afford guides from which to work.

Half way between "b" and "c" place a line to cut through the knee as in figure 2. About 1/4 of the lower leg from the floor, angle a line for the ankles.

This same fourth (dotted, fig. 2) above the knee line will give the starting point for the bulge of the outer thigh muscle (fig. 3). At the knee line start the calf muscles, stopping the inside one another 1/4 way up from the inside ankle (this point is a variable, but is never below the half-way mark of the lower limb). The outside muscle goes on down to meet the slope of the outside ankle bone. Notice how much (shaded area) is outside the triangle in fig. 4. Add remainder of leg and foot for complete fig. 5.

Of course these introductory devices are not presented as an open sesame to leg drawing in general. However, if one converges upon the problem from many angles he will add to his drawing skills.

When considering the basic <u>outside</u> lines of the leg there is a feeling of stagger at the knee (fig. 1). A preliminary oval at the knee line, then subsequent setting in of contour curves as in figures 2, 3 and 4 will bring the final drawing, figure 5.

As you make these sketches check out the sub-surface anatomy depicted in the diagrams on the after pages of this section. Become curious as to why a contour line is there. Something underneath causes it to so appear.

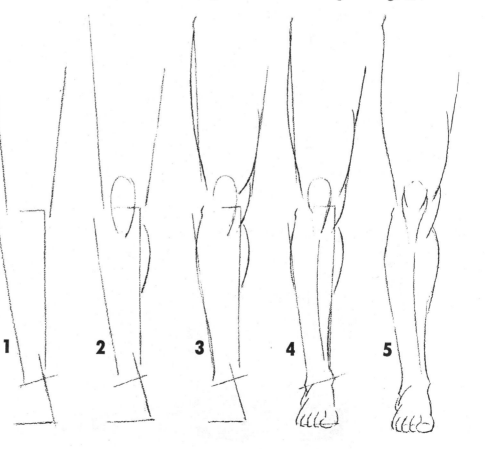

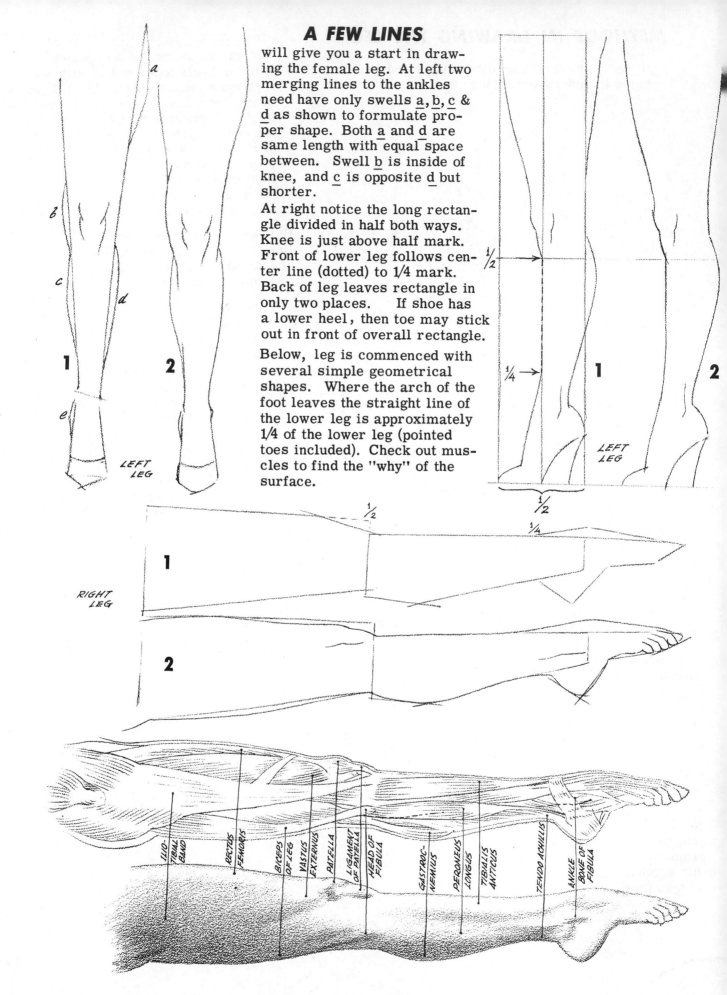

A FEW LINES

will give you a start in drawing the female leg. At left two merging lines to the ankles need have only swells a, b, c & d as shown to formulate proper shape. Both a and d are same length with equal space between. Swell b is inside of knee, and c is opposite d but shorter.

At right notice the long rectangle divided in half both ways. Knee is just above half mark. Front of lower leg follows center line (dotted) to 1/4 mark. Back of leg leaves rectangle in only two places. If shoe has a lower heel, then toe may stick out in front of overall rectangle.

Below, leg is commenced with several simple geometrical shapes. Where the arch of the foot leaves the straight line of the lower leg is approximately 1/4 of the lower leg (pointed toes included). Check out muscles to find the "why" of the surface.

LEFT LEG

RIGHT LEG

ILIO-TIBIAL BAND — RECTUS FEMORIS — BICEPS OF LEG — VASTUS EXTERNUS — PATELLA — LIGAMENT OF PATELLA — HEAD OF FIBULA — GASTROC-NEMIUS — PERONEUS LONGUS — TIBIALIS ANTICUS — TENDO ACHILLIS — ANKLE BONE OF FIBULA

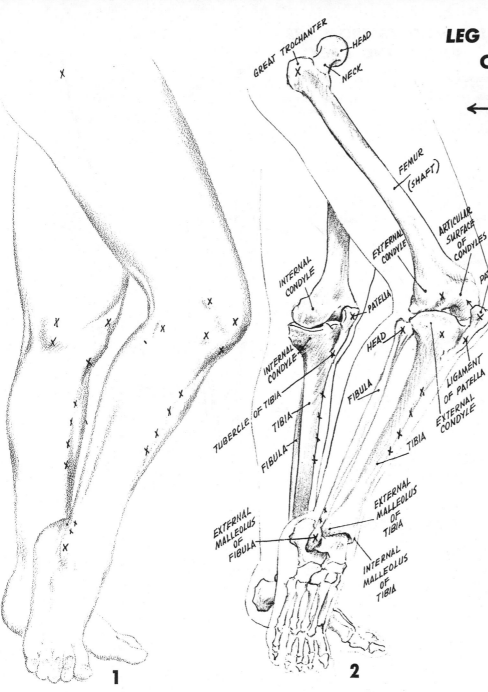

LEG BONES THAT SHOW ON THE SURFACE

← At the top the great trochanter of the femur should be mentioned, although it manifests itself chiefly when the leg is straight and carries the body weight. The femur shaft is always buried in muscle, but the external condyle of the femur shows (as well as the internal condyle on the far leg). The patella and its ligament beneath express themselves in every position. The external and internal condyles of the tibia are very close to the skin, but a thin layer of muscle rounds over them. The head of the fibula is very likely to show. Where the four x's are in tandem marks the front center of the tibia which is "practically out in the open." It looks as if the fibula shows, and this streak is most often there, but it is the peroneus longus muscle running alongside the fibula. The lower extremity of the fibula (external malleolus) pops out all the time. The direction of the light has much to do with the revealment of all these bones.

When the legs are bent, especially when the → feet are drawn under the thighs, the bones of the knee joints are made visible. Basically they assume the shape of modified squares (see fig. 5) — part of this, particularly the top inside, is muscle. "a", the external condyle of the femur, is higher than "b", the internal condyle, but muscle thickness over "b" evens off the top of the knee in appearance. The patella "e" slides down into the under groove or patellar surface of the femur, making the knee more or less flat on the front. The ligament of the patella is pulled over the tibia and shows slightly. The condyles of the tibia "c" and "d" square off the bottom part of the knee in this position.

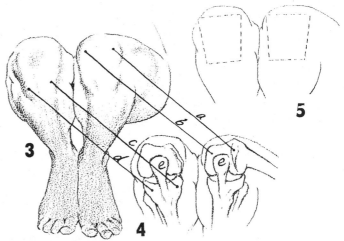

LEG MUSCLES FROM THE FRONT AND BACK

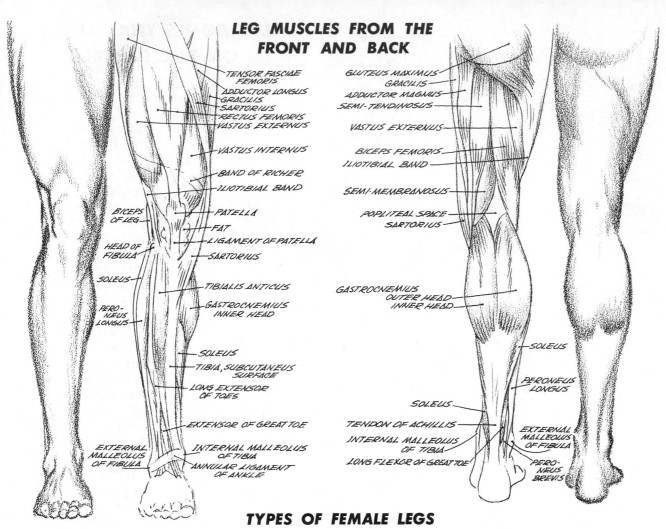

TENSOR FASCIAE FEMORIS
ADDUCTOR LONGUS
GRACILIS
SARTORIUS
RECTUS FEMORIS
VASTUS EXTERNUS

VASTUS INTERNUS

BAND OF RICHER

ILIOTIBIAL BAND

BICEPS OF LEG

PATELLA

FAT

LIGAMENT OF PATELLA

HEAD OF FIBULA

SARTORIUS

SOLEUS

TIBIALIS ANTICUS

PERO-NEUS LONGUS

GASTROCNEMIUS INNER HEAD

SOLEUS

TIBIA, SUBCUTANEUS SURFACE

LONG EXTENSOR OF TOES

EXTENSOR OF GREAT TOE

EXTERNAL MALLEOLUS OF FIBULA

INTERNAL MALLEOLUS OF TIBIA

ANNULAR LIGAMENT OF ANKLE

GLUTEUS MAXIMUS
GRACILIS
ADDUCTOR MAGNUS
SEMI-TENDINOSUS

VASTUS EXTERNUS

BICEPS FEMORIS
ILIOTIBIAL BAND

SEMI-MEMBRANOSUS

POPLITEAL SPACE
SARTORIUS

GASTROCNEMIUS OUTER HEAD INNER HEAD

SOLEUS

PERONEUS LONGUS

SOLEUS

TENDON OF ACHILLIS

INTERNAL MALLEOLUS OF TIBIA

LONG FLEXOR OF GREAT TOE

EXTERNAL MALLEOLUS OF FIBULA

PERO-NEUS BREVIS

TYPES OF FEMALE LEGS

Below are several different types of female legs. Check out the interior structure on No. 1 and No. 2 by reference to the muscles listed above. No. 3 is an example of subcutaneous fat concealing all but general bone and muscle shape beneath; nevertheless, it is still there. Compare the heavier type No. 4 with the slender No. 5 legs and note how the basic under-pattern is the same.

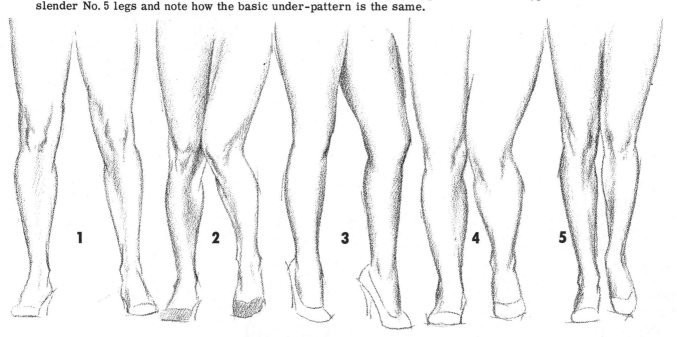

1 2 3 4 5

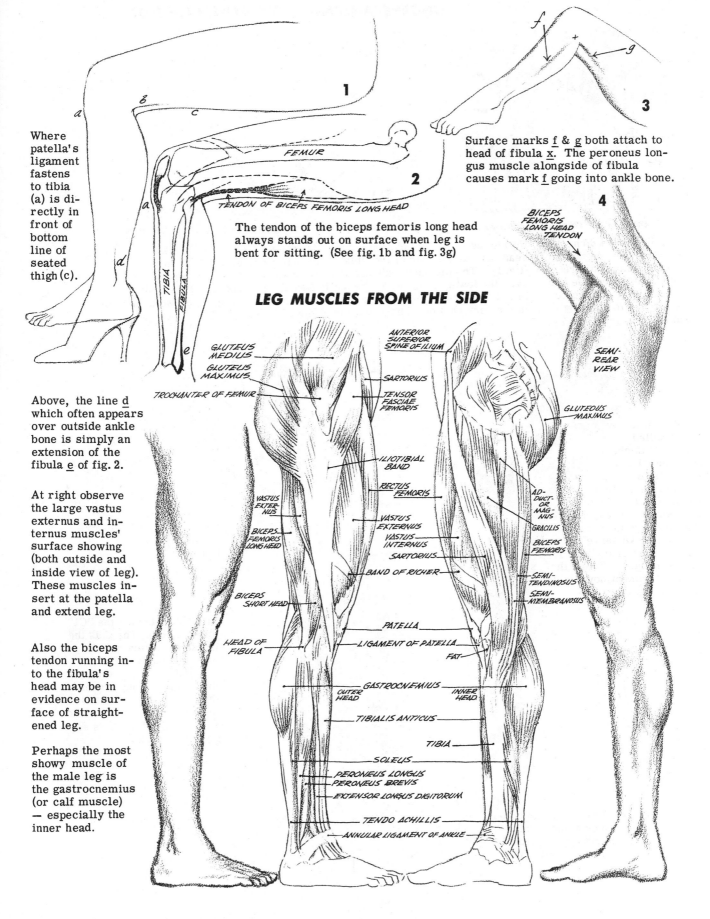

1

2

3

4

Where patella's ligament fastens to tibia (a) is directly in front of bottom line of seated thigh (c).

FEMUR

TENDON OF BICEPS FEMORIS LONG HEAD

TIBIA

FIBULA

Surface marks f & g both attach to head of fibula x. The peroneus longus muscle alongside of fibula causes mark f going into ankle bone.

The tendon of the biceps femoris long head always stands out on surface when leg is bent for sitting. (See fig. 1b and fig. 3g)

BICEPS FEMORIS LONG HEAD TENDON

SEMI-REAR VIEW

LEG MUSCLES FROM THE SIDE

Above, the line d which often appears over outside ankle bone is simply an extension of the fibula e of fig. 2.

At right observe the large vastus externus and internus muscles' surface showing (both outside and inside view of leg). These muscles insert at the patella and extend leg.

Also the biceps tendon running into the fibula's head may be in evidence on surface of straightened leg.

Perhaps the most showy muscle of the male leg is the gastrocnemius (or calf muscle) — especially the inner head.

GLUTEUS MEDIUS
GLUTEUS MAXIMUS
TROCHANTER OF FEMUR
ANTERIOR SUPERIOR SPINE OF ILIUM
SARTORIUS
TENSOR FASCIAE FEMORIS
ILIOTIBIAL BAND
RECTUS FEMORIS
VASTUS EXTERNUS
VASTUS EXTERNUS
VASTUS INTERNUS
BICEPS FEMORIS LONG HEAD
SARTORIUS
BAND OF RICHER
BICEPS SHORT HEAD
HEAD OF FIBULA
PATELLA
LIGAMENT OF PATELLA
FAT
GASTROCNEMIUS
OUTER HEAD
INNER HEAD
TIBIALIS ANTICUS
TIBIA
SOLEUS
PERONEUS LONGUS
PERONEUS BREVIS
EXTENSOR LONGUS DIGITORUM
TENDO ACHILLIS
ANNULAR LIGAMENT OF ANKLE
GLUTEOUS MAXIMUS
AD-DUCTOR MAGNUS
GRACILIS
BICEPS FEMORIS
SEMI-TENDINOSUS
SEMI-MEMBRANOSUS

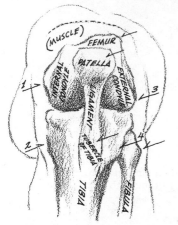

BENT LEFT KNEE FRONT VIEW

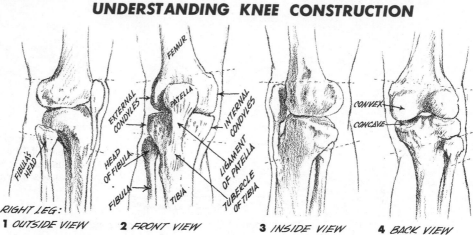

RIGHT LEG:

1 OUTSIDE VIEW **2** FRONT VIEW **3** INSIDE VIEW **4** BACK VIEW

Consider the above 8 check points which show on the surface; four (numbered) are big bone condyles inside and out. Here ligament of patella is stretched to limit by flexion action.

Notice the patella's position between the femur's condyles (fig. 2). The fibula's head sets to the rear of the tibia's external condyle, yet it is on the outside (fig. 1). The big bone ends are like two clenched fists, the upper (femur) sliding over the lower (tibia) when the leg is flexed or extended. This gliding action is aided by the double convex rounds on the back of the femur which articulate in the very shallow cups at the top of the tibia (see fig. 4).

At right lower limb is pulled back under thigh. Locate the check points (x's) of fig. 2 in the knee's surface anatomy fig. 1. These check points correspond to the interior bone drawing of fig. 3. Observe the squared effect of fig. 2 as it appears in fig. 1. Trace the patella's ligament down middle of knee in fig. 1.

At left remember the "CU" (black lines). The C is the inside sartorius rounding over the condyles. The sides of the U are the visible skin markings from the semi-tendinosus and the biceps femoris beneath. The bottom of the U is simply a fold crease.

From the outside notice how the contour lines run. Lines a and b point toward each other and pass in front of knee rumples 1 and 2. Calf line c runs in and up.

At right follow lines a and b as leg turns from side to back.

TYPES OF KNEES

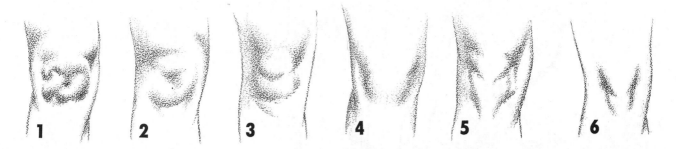

1 **2** **3** **4** **5** **6**

FEMALE Above, surface anatomy of female knees, right leg, as contrasted with male knees below. In each case the patella or kneecap is just above center. 1. Squared with two horizontal rumples, one underneath other. 2. Rounded with center depression. 3. Overlapping rounds; bottom round of fatty tissue concealing ligament of patella appears larger than top round encasing patella. 4. Large "V", fleshy thickness covering underparts. 5. Marked revealing of understructure (see interior diagrams) can and does appear on some female knees. 6. Type most often drawn, double round with top overlapping and bottom smaller (being ligament partially outlined).

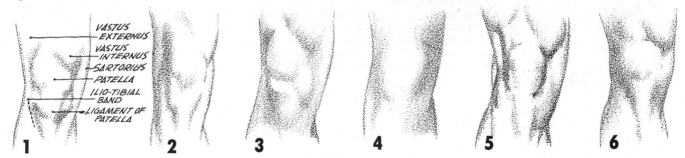

VASTUS
EXTERNUS
VASTUS
INTERNUS
SARTORIUS
PATELLA
ILIO-TIBIAL
BAND
LIGAMENT OF
PATELLA

1 **2** **3** **4** **5** **6**

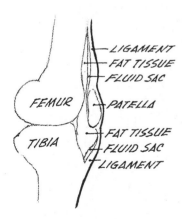

LIGAMENT
FAT TISSUE
FLUID SAC
FEMUR
PATELLA
TIBIA
FAT TISSUE
FLUID SAC
LIGAMENT

MALE For the most part male knees exhibit more muscle make-up than female (see six examples above). No. 5 most highly developed; No. 4 least developed. Observe prominence of vastus muscles protruding just above knee. Notice ligament of patella pushing out at bottom of knee's center. See how entire knee sets in "V" of lower attachment on tibia of ilio-tibial band & sartorius.

Above is cross section of knee from side showing why there is rumpling of contour when leg is straightened. Besides protection of joint, patella acts as pulley sliding over middle notch of femur when front thigh muscles pull ligament attached to tibia. Thin fluid sacs called bursa lubricate sliding.

Compare 12 surface illustrations above with right diagram.

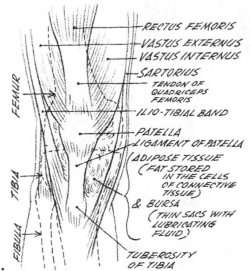

RECTUS FEMORIS
VASTUS EXTERNUS
VASTUS INTERNUS
SARTORIUS
TENDON OF
QUADRICEPS
FEMORIS
ILIO-TIBIAL BAND
PATELLA
LIGAMENT OF PATELLA
ADIPOSE TISSUE
(FAT STORED
IN THE CELLS
OF CONNECTIVE
TISSUE)
& BURSA
(THIN SACS WITH
LUBRICATING
FLUID)
TUBEROSITY
OF TIBIA
FEMUR
TIBIA
FIBULA

ANTERIOR SUPERIOR
ILIAC SPINE
VASTUS EXTERNUS
RECTUS FEMORIS
SARTORIUS
VASTUS INTERNUS
PATELLA
LIG.
TIBIA
FEMALE

HELPFUL POINTERS IN DRAWING THE LEG

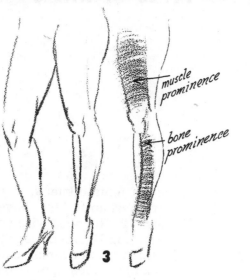

1

HIGH OUTSIDE — LOW INSIDE

CONVEX

CONCAVE

muscle prominence

bone prominence

3

FEMUR

TIBIA

FIBULA

4

In fig. 1 notice the (highly developed) muscle "bulge" setting of the vastus externus (up) and the vastus internus (down). Also, follow the lower leg's inside front shaping. In fig. 2 see the surface grouping of protrusions above and below knee. Fig. 3 shows the femur concealment and tibia "exposure." In fig. 4 a lean, heavy-boned leg is pictured — remember how fibula sets lower, top and bottom, than tibia.

2

5

A point that cannot be overemphasized is the staggering of the upper and lower leg sections. Look for and record this fact in your drawing. The leg is not just straight up and down throughout.

LINE GOES ON TOP

LINE GOES UNDERNEATH

6

Above, observe the "v's" (dotted lines on either side) showing the feeling of wedging from top to bottom. Too, the inside lines in black are on top of the double back lines.

SARTORIUS

RECTUS FEMORIS

VASTUS EXTERNUS

VASTUS INTERNUS

GASTROCNEMIUS

7

Look carefully at the above leg modeling, then verify the reasons for it by sounding out the muscles beneath. The legs in illustrations 1, 6 and 7 are all highly developed for muscle definition

THE LEG IN RELATION TO THE REST OF THE FIGURE

In fig. 1 distances <u>a</u>, <u>b</u> & <u>c</u> are comparable. Of course, the shoulder girdle is extremely mobile, so <u>a</u> will vary some.

1

2

3

In fig. 2 thigh is used as radius for circle. This is the short norm proportion. In fig. 4, as in fig. 1, lines <u>a</u>, <u>b</u> & <u>c</u> are equal. Line <u>c</u> goes to root of fingers. Heel <u>never</u> extends beyond buttock in this position.

4

5

Above, fig. 3: Shoulder to elbow equals buttock to knees (a). Elbow to finger tips equals knee to heel (b).

Left, fig. 5: When limbs are folded completely together, bottom half under top, crease in arm resembles that of leg. <u>Both</u> point toward floor.

Right, figs. 6, 7, 8 & 9 are various views of legs folded under body. When heels are directly beneath, then thigh predominates (see also fig. 4). In fig. 8 left foot is placed to outside so more of lower leg is visible.

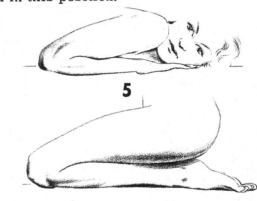

6

7

8

9

FUNDAMENTALS OF FEET

Some part of the foot always angles off from the leg line, whether it is supporting the body weight or not. Learn of the ankle position early, remembering the inside ankle is higher and farther toward the front than the outside ankle. The big toe tends to keep flat with the ground; the other toes bend over and reach down to the ground.

The foot is slightly longer than the height of the head. The hand is about 2/3 the length of the foot. When it is pressed to the floor, the overall width of the foot is as wide as the hand. The female proportions are somewhat less. (The figure that is 8-plus heads high may have feet 1 1/3 heads in length and 1/2 head in width.)

Together the feet form a crossways spring. The tops of each instep and insole curve toward each other.

From the inside the foot is built into a modified spring. The heel acts as a foundation for bearing bulk of weight. Fore part of foot acts as spring to absorb shock.

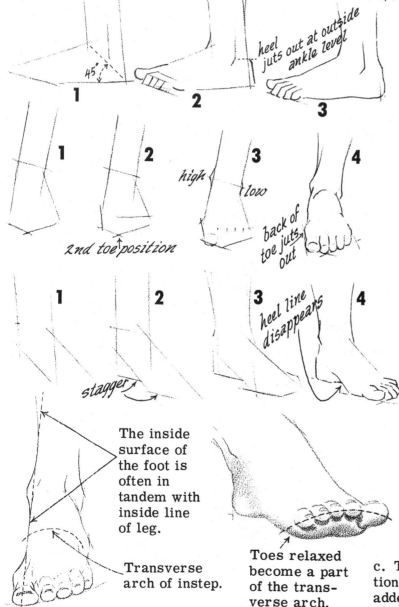

The inside surface of the foot is often in tandem with inside line of leg.

Transverse arch of instep.

Toes relaxed become a part of the transverse arch.

The big toe and ball pad behind it jut out like the thumb of the hand -- especially under pressure.

THE ARCHES IN ACTION

a. The inside longitudinal arch just behind the big toe plays the major part in cushioning the step.

b. The outside longitudinal arch flattens to the ground and gives the body sideways stability.

c. The transverse arches along the cross sections of the middle and front of foot give added shock absorption.

d. The half-moon shaped curve running around bottom of foot aids in overall equipoise. (Foot lifted to illustrate; actually heel hits floor first)

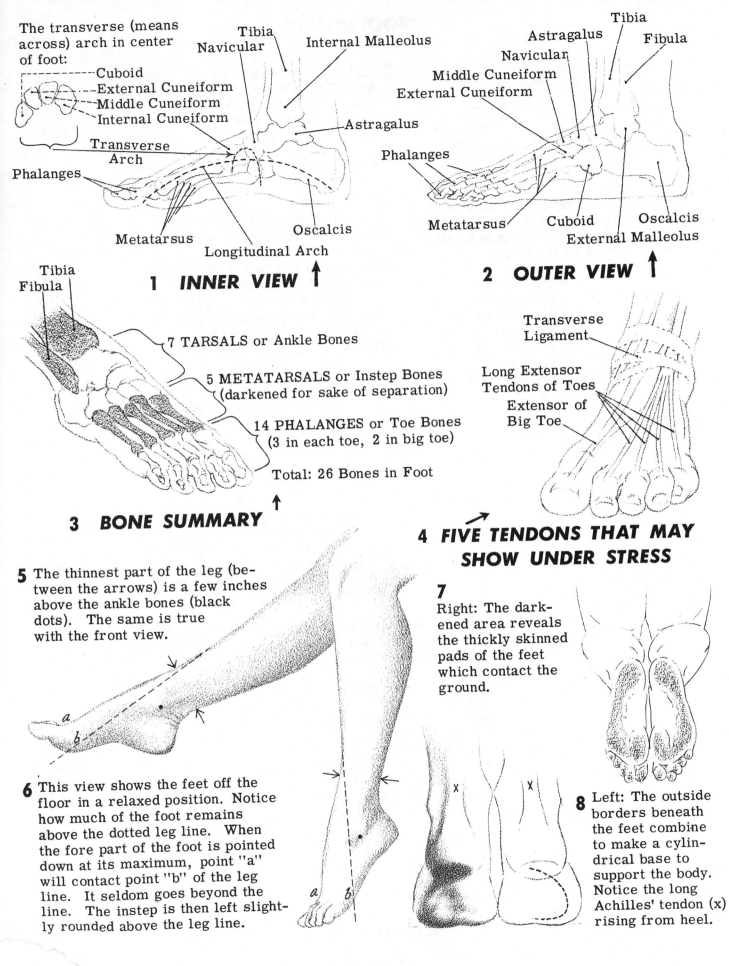

The transverse (means across) arch in center of foot:
- Cuboid
- External Cuneiform
- Middle Cuneiform
- Internal Cuneiform

Transverse Arch

Phalanges

Metatarsus

Longitudinal Arch

Oscalcis

Tibia
Navicular
Internal Malleolus
Astragalus

1 INNER VIEW ↑

Astragalus
Navicular
Tibia
Fibula
Middle Cuneiform
External Cuneiform

Phalanges

Metatarsus

Cuboid

External Malleolus

Oscalcis

2 OUTER VIEW ↑

Tibia
Fibula

7 TARSALS or Ankle Bones

5 METATARSALS or Instep Bones
(darkened for sake of separation)

14 PHALANGES or Toe Bones
(3 in each toe, 2 in big toe)

Total: 26 Bones in Foot

3 BONE SUMMARY ↑

Transverse Ligament

Long Extensor Tendons of Toes

Extensor of Big Toe

4 FIVE TENDONS THAT MAY SHOW UNDER STRESS ↗

5 The thinnest part of the leg (between the arrows) is a few inches above the ankle bones (black dots). The same is true with the front view.

6 This view shows the feet off the floor in a relaxed position. Notice how much of the foot remains above the dotted leg line. When the fore part of the foot is pointed down at its maximum, point "a" will contact point "b" of the leg line. It seldom goes beyond the line. The instep is then left slightly rounded above the leg line.

7 Right: The darkened area reveals the thickly skinned pads of the feet which contact the ground.

8 Left: The outside borders beneath the feet combine to make a cylindrical base to support the body. Notice the long Achilles' tendon (x) rising from heel.

101

"FOOTNOTES"

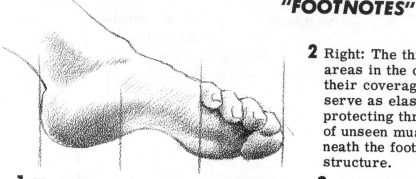

2 Right: The three bottom areas in the order of their coverage. They serve as elastic pads protecting three layers of unseen muscles beneath the foot's bone structure.

1 The little toe may come back as much as 1/3 the length of the entire foot. In most cases, however, it is located back around 1/4 the length.

3 The outer ridge of the sole pad (between dotted lines) tends to bulge a little -- especially is this true as age comes on plus excessive weight. It's more noticeable among peoples who go barefoot.

4 The several changes of planes down the top of the foot are suggested by the dotted line at the left.

5 Unlike the finger-bone phalanges the toe-bone phalanges cannot move about as dexterously. On "tip-toe" they'll spread when forced against the floor.

6 Toes turned under mean the bottom flexor muscles of the toes gather and rumple the fleshy sole pads and thinner skin of the arch. However, pad of heel always remains smooth under any circumstance.

7 In walking, the outside back of the heel marked "x" strikes first, then the rest of the foot settles into contact with the ground. The feet do not track parallel with each other. You draw the feet of a walking man pointing out slightly.

8 Some toes when relaxed will bend down at nearly a 90 degree angle. This does not apply to the big toe; it usually has an inward set rather than downward when forced out of line. This extreme angle is often due to the torturous design of certain shoes.

9 When foot is pointed down, the outside ankle region rounds out (as per dotted line). This is because point "x" which has been a hollow is filled in by knob extremity of the big leg bone (tibia). Black dot is ankle bone.

DRAWING WOMEN'S SHOES

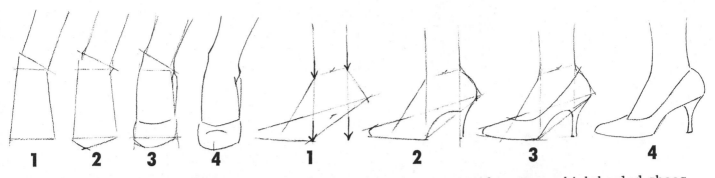

1 **2** **3** **4** **1** **2** **3** **4**

1. Start with elongated trapezoid shape. (Remember, in all blocking such as this, sketch <u>lightly</u>!) This is front foot thrust forward in typical stance where back foot carries bulk of body weight. If leg lines slant into foot as is the case here, and arch side of foot is exposed, then ankle line will be more severely tilted.

2. Sketch in ankles. Added toe lines will form a triangular shape beneath trapezoid.

3. Indicate shoe's instep line which is partly dependent on style. This usually occurs just behind root of toes. Draw sides of shoes across ball of foot. These will appear just beyond trapezoid's sides. Back of heel may barely show. If heel is centered, rear part of shoe will be out of sight.

4. You may or may not have some evidence of break where top plane of toe section starts up on instep. Here it is suggested. Too, there is a small vertical line at point where planes retreat on either side of shoe.

The artist is called upon to draw more high-heeled shoes than any other kind. The above diagrams, both left and right, are of the same type of shoe. The soles of these feet are not flat with the eye-level of the observer. They represent the position most needed by the artist in portraying the model as she appears in most settings, i. e. , with her eye-level on yours. The front view at the far left is a left foot set out to balance the body being supported by the above right foot — inside view. With the exception of the ankle placement being different (lower outside), the outside view is the same. In the high heel the arch itself appears essentially the same from both sides.

1. Sketch the leg lines cutting through the trapezoid and the modified triangle beneath. The back leg line (when limb is in vertical position) always points directly to cap of shoe's heel. Front leg line points to spot where sole leaves the floor. Because foot is tilted down, heel protrudes farther out in a high-heeled shoe than in a lower heeled shoe. Notice plane of toe section is in line with extreme rear base of heel.

2. Draw shoe arch as wide as leg is thick. Toe front depends entirely on style, but allow room for toes inside shoe. Round heel into back triangle of trapezoid, and add back arc for heel column.

3. Sketch in sides of shoe and inside of heel column. See how root of heel column merges into high point of arch. Round sole slightly, as it is somewhat below eye-level.

4. Observe how top plane of toe section disappears around where instep enters shoe. This again is because eye-level is above and you are looking down, as it were, into shoe's opening. If foot looks wrong, check it out with the foregoing sequences. Draw several until they look right.

THE BASIC FORM

For foot protection and warmth most of humanity wear some kind of soles on their feet. One of the problems in shoe design is to hold this sole to the foot itself. Consequently, the shoe uppers must conform in some way to the cross-sectional shape of the foot. Study and keep in mind the basic form of the bare foot.

A few terms that help identify areas:

instep
ball of foot
arch of sole
heel
rim of sole

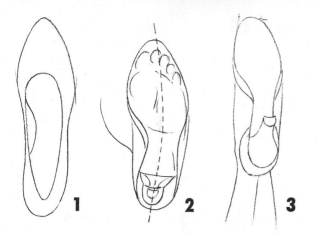

1 **2** **3**

Looking into the shoe on the left shows how the foot flares outward from the bottom of the leg. Refer to the shoe's opening in relation to the sole beneath.

The second sketch depicts the shoe from underneath. Two heels are suggested: a half block and a more pointed heel. In both cases you are seeing the front of the heel column which means the toe is somewhat closer to you. In the next sketch you see more of the back of the heel column which means the toe is farther away. Also, since the heel tip is to the right of center, the whole foot is seen more from the inside than the outside.

In the above drawing a portion of the sole is showing. Extract the heel of each foot and you can picture the anatomy beneath in a more or less shoeless state. The dotted line is "drawn through" to reveal how the heel is attached.

4

6

Here is the left foot from above. Learn to "draw through" (dotted lines) in order to check construction. Not much of shoe heel is in sight. Observe shoe's opening into which foot is placed.

7

Here is the right foot from the underside. More of the heel is seen than at left. Foot's side barely shows. Front leg line disappears behind instep. Heel cap is on level with the sole of the ball. "Imagine" foot inside.

5 When legs are tilted at an angle such as at left, bottoms of feet may show. Foot nearest has toe pointed more toward viewer, hence it is drawn shorter than other foot which is more side view.

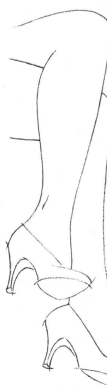

8 Some of shoe's arch as well as sole may be exposed when foot is lifted. Several heel widths are indicated here.

9 In the semi-front from below notice the deep niche effect along inside of heel.

10 In drawing women's "flats" (extreme right) the basic rules are quite similar to those used in blocking in men's footwear. The styles are more variable, particularly across the uppers.

FEET AND FASHION

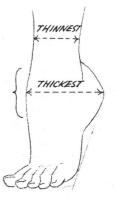

By now you may have remembered that the thinnest part of the human leg is from two to three inches above the ankles. From the side the thickest part of the foot is directly across from the back edge of the heel. It may come anywhere through the tarsal bones (area of the bracket). In the female this section may be smoothly rounded by a fill of subcutaneous fat, or in both male and female any one of these bones may show slightly beneath the surface.

Women's shoe fashions change with the wind. However, since madame's foot remains essentially the same her shoes will always have some kind of toes, sides and heels. On occasion the sides disappear, leaving the sole to be held on by a toe or heel attachment. There are hundreds of variations, but at left and below are offered some of the more basic patterns. Heels may be shortened easily.

Superimposed over the foot at the right are a number of suggested innovations in shoe designs. All of the lines and changes comply with the basic foot shape. Through women's magazines and ads one can learn of the current fashions to use in answer to the immediate need.

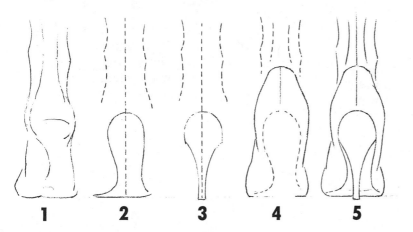

1 2 3 4 5

In order to understand the breakdown of the foot-in-shoe from the rear, the above floor line has been placed on the eye-level. Notice the sole's (2) concave allowance for the arch on the inside left. See now the top of the heel (3) coincides with the top-back of the sole (2). Observe how the shoe's upper encases the heel (4), and how the heel column of the shoe lines up with the sole in the completed diagram (5).

Most of your demands will be to draw the shoe with the eye-level well above the floor, in which case the heel tip will appear below the front ball of the foot (see above).

DRAWING MEN'S SHOES

1 Block in foot, using simple straight lines of trapezoid shape. Base of trapezoid swings to outside. In average front view, outside leg line, if extended, will cross on or near root of center toe. Sketch oblique ankle line.

2 Connect bottom toe lines with base of trapezoid. Set in curve of shoe upper over top line of trapezoid. Sketch curve of instep and repeat curve for seam over shoe toe. Notice suggestion for side of heel section at rear of shoe.

3 Though it is not necessary, one should be able to show foot encased within shoe outline. There will be a little play between front of shoe toe and foot toe. Observe line of break where foot becomes leg. Top of shoe tongue appears a little below this.

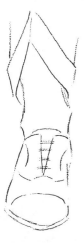

4 In nearly all male footwear there is the laced V coming down the instep. The point of the V is about half way to toe. There are multiple patterns on the shoe uppers. Extreme front of shoe sole may be pointed, rounded or squared.

With eye-level almost on floor, witness evidences of the transverse arch repeated along the visible part of the shoe. From this angle the heel barely shows.

5
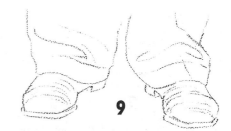

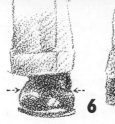

6

Notice big toe allowance. Arrows: where toe area becomes instep.

In semi-side view, inside of shoe heel begins to show. Observe pant cuffs in these diagrams.

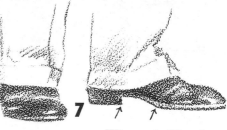

7

Heel sole is not as wide as front ball sole; may not show at all.

Where ball sole leaves ground is about 1/2 overall shoe length. Heel about 1/4. Styles vary somewhat.

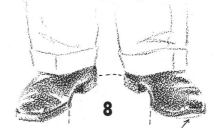

8

Discern how arch effect carries across inside of shoes. With eye-level low, underpart of toe tip may start to show (especially in long-worn shoes).

9

No part of the human attire so reveals the day-by-day struggle of life than a pair of shoes. The more the wrinkles, the more the oval sketch lines may be drawn.

MAKING SHOE DRAWING EASIER

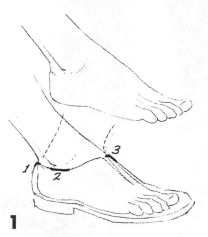

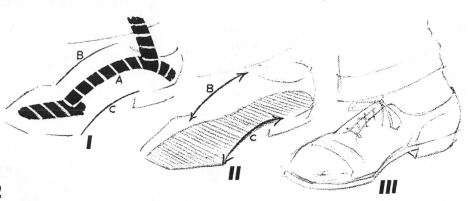

1

The topmost rim of a man's shoe is concave under the ankles. This line merges into a convex line over the instep. Point 2 (the concave) must clear the outside ankle bone when toe is bent downward. Point 1 is predetermined by foot's being in this position also — it must clear the back leg line. Point 3 must not interfere with leg when brought forward as per dotted line. The function of the rim's design will help one remember its shape.

2

The spring-like arch of the foot is more apparent in the shoe from the inside view. Figure III is a typical angle often drawn by the artist. Reverting to figure I, study the spring-like core of the arch marked A. See how lines B and C tend to run parallel with it. In fact, the whole center section seems to reach down to the floor.

In figure II notice the curved sweep of these same two lines B and C. Line C is the inside of the sole which has been made visable here. Line B is the instep which is roughly 1/3 of the shoe's upper. Feel out the center arch section while sketching figure III.

3

Left: There are two arcs in the cut of the shoe sole. The inside arc A is always more pronounced to accommodate the natural arch of the foot. Arc B in some soles is barely discernible. Black dots are where the arcs break and the sole edge curves in toward toe. Shaded area contacts ground. Contact along dotted line may vary with heel height. Style changes alter contour somewhat.

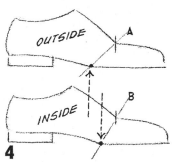

4

Above: Sole contacts ground at point (black dot) farther forward on inside of shoe than outside (see arrows). Lines A and B show relation between contact points and break of instep.

5

Since most men's shoes are dark colored and are supposed to shine, it is well to consider where the highlights are most likely to appear. Usually there is a vertical strip of reflected light on the back of the heel section. The comparative flat of the center sides carries a monotone except where it bends under to meet the sole. Probably the changing planes of the exposed toe will have several flecks of light. A shoe when it has been worn has a slight rocker effect on the bottom and is not flat with the floor.

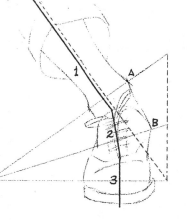

6

The ankle may bend left or right to nearly a 45° angle. The shoe's upper may give a little to comply. Hump A is bone and B is shoe. There are 3 changes of direction so numbered. Imagine the trapezoid shape (discussed earlier) blocked over foot beneath ankle line.

FEET FIRST

1

It is interesting to note that in the cut of most men's soles the inside line at the arch (black), if extended (dotted), crosses the opposite extremity of the toe (x). The big toe region (A) is on the inside of this extended line.

2

From the rear men's pant cuffs often cover part of the shoe. The heel in this position is somewhat like a squat barrel with varying degrees of the barrel's waist and the front toe areas showing (or none at all).

3

When a walking foot is pointed toward you the sole of the ball may scoop up like the runner on a rocking chair. The bottom of the heel may hardly show.

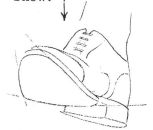

4

Keep in mind that the inside ankle bone is not only higher off the ground but farther forward than the outside ankle bone. The widest part of a shoe is at the bottom of the shoe laces.

5

As the sole is exposed observe how the side of the uppers narrows.

108

As clothes conform to the body they of necessity must fold in places. The kind of fold the cloth takes depends upon its location and texture. It is important to know what body shape is beneath the material, hence the foregoing study on anatomy. Always there is a certain amount of bone and muscle structure revealed through the cloth.

SIMPLE FOLDS FROM BODY PROTRUSIONS

1 The hump of the knee (condyles of the femur) causes the trouser fabric to yield in a manner similar to this sketch.

2 When the elbow is bent folds must occur in the sleeve. In the outer view the apex (olecranon of the ulna) of the joint pushes into view.

3 Since any covering must go around or fall over the big shoulder muscle (deltoid), there usually are folds here, particularly with arm movement.

4 Folds of some kind may occur off the high inside of the shoulder blade (vertebral border of scapula). Any body protrusion can be the originating point for folds, depending upon apparel's design.

5 At the point of the nipple of the female breast a few light folds may occur, or in the vicinity beneath the breast the fabric may change its contour into slight combinations of folds and shadow.

6 In the hang of a skirt from the side very often long drape folds find their beginning at the hip bone (front crest of iliac — check pelvic bone).

SIMPLE FOLDS FROM BODY INDENTIONS

Whereas, all of the foregoing are examples of folds which have their origin at points of protrusion, there are other folds which come from points of indention sometimes referred to as "tuck points."

2 Natural tuck points: where the fabric is folded over in the making (armpits and crotch).

1 Forced tuck points: made by bends at the joints (knee, elbow, wrist, etc.) or flexing of the torso.

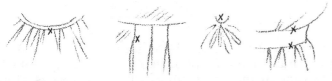

3 Tuck points brought on by stitching.

4 Tuck points caused by outside pressure such as chair bottoms, table tops, and outside influences.

VARIOUS TYPES OF FOLDS

Folds may be of many sizes and take varied shapes. Often they will resemble letters of the alphabet such as the above Y, X, S, U, V, and P (the latter being one fold passing beneath another). Folds may be loose and open or tight and compressed as figures 3, example S, illustrates. Clothing folds are to be seen wherever there are people. Form the habit of watching them at times to see what they do. Learn from your own person and a mirror. Flex your legs, arms, and torso.

Folds always have some point of support, whether internal, 7 & 8, or external, 9. They tend to radiate from these points either by gravity or other forces. Fabric lying in a clump on the floor or floating in wind or water is an exception but is seldom related to the human figure.

Nearly all folds in clothing are either crush folds or tension folds. In figure 10 the crush is without tension. In 11 there is tension to the left. In 12 the tension is spread. In 13 there is twist.

In the illustration at the left is an example of a simple tension fold (from x to x) and a simple crush fold (*). The material here is between medium and heavy weight. A lighter material would have thinner folds and several more of them.

PLEATS
"Y" FOLD
"X" FOLD
"S" FOLD
TELESCOPIC FOLD
DRAPE FOLD
FLAP FOLD
GATHERS
"U" FOLD (CIRCULAR)
FOLD PASSES ANOTHER
CONTOUR PASSES
"V" FOLD (ANGULAR)
RIPPLE FOLDS
TIGHT COMPRESSION FOLDS
TUBE FOLDS FROM LAP INDENTION
HANGING FOLDS FROM KNEE PROTRUSION
CHANGE OF PLANE
CURTAIN FOLD HIGH
CURTAIN FOLD LOW
RELAXED FLOOR FOLD

The seated figure is wearing a garment which has been improvised to display nearly every known type of fold. It is highly unlikely that all of these would appear in any dress of fashion at the same time. The purpose is simply to help one identify types various kinds of folds.

FOLDS IN LIGHT AND SHADOW

1 The above line could conceivably be the cross section of folds in cloth lying on a table. It illustrates a vital factor about folds that happen anywhere. Most likely there are a limited number of light sources involved. Because of this there usually are shadows and partial shadows on or below the folds themselves. In this diagram the arrows represent the source of light. The parts of the line done in pencil are the areas more directly exposed to the light. The parts which are dotted are in partial shadow, and the parts of the line in black are in total shadow.

This explains why some folds or parts of folds are drawn heavily while others are drawn lightly. Too, it helps the artist to understand that one side of a fold may be treated with a coarse line; whereas the other side of the same fold will call for a less prominent shade strip of some kind.

2 Above are sample folds simply done showing a dark, a light and a middle tone or gray. One may draw two lines of varying width, or a heavy line with a parallel shade strip of little lines. Brush, pen or pencil may be used by themselves or in combination.

3 At left is a drawing using brush alone. Below are brush lines followed up with pencil. At right is a sketch employing brush, pen and pencil with a few strips of white painted on the front skirt folds.

111

THE FEMALE FIGURE AND CLOTHING

A　　**B**　　**C**

Above are sequences showing how one may (A) block in the figure, (B) refine it enough to be sure of its correctness and (C) add attire which will fit naturally. The extent of the under-drawing in the development of a clothed figure is up to the individual artist. One thing sure, when he is through, the figure must be able to reside within the garment. When a sketch nearing completion looks wrong, many artists throw a tissue over it and "draw through," returning all or parts of the sketch to the basic anatomy. This way the parts which emerge from the clothing will "belong" to the figure beneath. From the start all underdrawing must be put down lightly and forever subject to change.

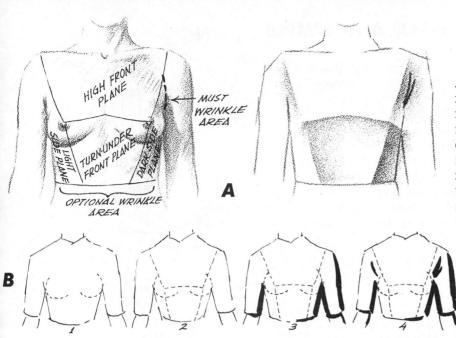

CLOTHING THE UPPER TORSO

At the far left is the female chest region with an indication of covering planes. Whether the garment is tight or loose fitting makes some difference. The kind of material, its design and lighting are other factors to consider. The lighting theme is further carried out in the sketch at the immediate left.

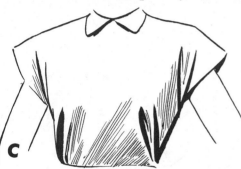

Begin sketching lightly as in 1 & 2; express darks on contour opposite light source as in 3; set in folds above armpits 4; add folds below breasts 5; lay values in to denote planes 6.

Chief folds come off shoulder into armpit and off breast into waistline. Pen and brush.

When body weight is thrust on one leg as in figure at right, high hip calls for lowering of shoulder on that side. Breasts stay with shoulders; hence folds from both breasts swing toward high hip. D, E & F are pencil treatments. D is the more formal line; E is the pencil slash; F is the multiple informal line.

D

Develop penciling very lightly at first. Add bold, blunt strokes later.

E

F

Pencil shade placed over brush folds.

G

D: Prismacolor Black 935 pencil on Coquille Board fine. E: same pencil on layout paper. F: HB drawing pencil on charcoal paper. G: Hunt 99 pen, No. 2 brush, ink, 935 pencil on Coquille Board fine.

FOLDS — COMPLEX AND SIMPLE

Though there are many different techniques of rendering, here are some pencil (1), pen (2) and brush (3) suggestions for handling folds. Remember the material is soft and flexible, so keep your treatment light and airy. Notice the various "weights" of lines in each medium.

In the pencil see how small masses of value are obtained with sketchy parallel lines. Look carefully at the line groups in the pen drawing. There are some single lines and double lines. For emphasis or shadow a triple-plus line may be used.

In a brush drawing the average individual line tends to be heavier than when done in pen; however, relief from monotony can be had by using some thin, even broken lines (particularly on the contours of the sides from whence the light comes). Slight folds call for the thinner, more insignificant lines.

Above is a brush drawing with folds reduced to a minimum. The quantity of folds shown is always up to the artist. One does not have to put them all in. In the circles are follow-up folds or secondary folds (in this case done with pen). They depict more of a low or indention in the fabric rather than an actual tuck-under. Practice combining brush and pen folds. At first use them sparingly. Plain areas make the folds that do occur more meaningful and pleasing.

114

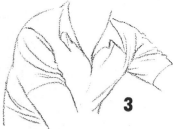

Below is an expression of the cylindrical forms found in the seated figure. To one side are details of folds taken from the finished drawing. Ascertain how these folds conform with the cylinders. When you draw folds, take them around the body part which supports them. Always take into consideration the elliptical cross section of the arm, leg, waist, etc. before you drape clothing about it.

MAKING FOLDS COMPLY WITH THE FIGURE

1

3

In fig. 3 check out the neck ellipse, the arm ellipse, the chest ellipse and the shoulder ellipse. In the arm of fig. 4 there are two cylinders retreating from the elbow.

4

In this figure there are about two dozen different cylindrical forms linked to each other. See anatomy in terms of cylinders and your folds will come easier.

2

5

Some materials are springy and refuse altogether to lie on the supporting form (see fig. 5). They take on loops instead of angles. Still they cover the shape by virtue of one loop's going behind the other.

In fig. 6 the ellipse of both waist and hemline are subtle but there nonetheless.

6

A **B** **C**

By this time the student should have experimented with various basic body frames. Fig. A is but a suggestion. Some of the polishing of fig. B could be left out before the clothing of fig. C is added.

Any fully attired figure drawing should be evolved with the artist understanding what is going on in the process. There may be a few happy accidents in guess work, but the one who can produce consistently is the artist who has a comfortable knowledge of figure fundamentals. As anatomy is studied, the total concept will be without the gaps which previously proved bothersome. If this concept is soundly ingrained from tireless practice then one can more successfully slenderize the figure for fashion or broaden it for mural work or adapt it in other ways to meet specific requirements.

NOTES ON SIMPLIFIED BODY FRAMES

Earlier in this book successive stages were given on figure understructure, starting with the head oval, the plumb line from the neck pit, the shoulder and hip lines, etc. As one learns proportions and the proper setting of the parts, he will find it easier to mark off the areas, top to bottom, of the figure. A certain sized body part will automatically call for related parts properly proportioned. In a very real sense one learns to visualize the whole almost simultaneously with the setting down of the parts. At first these parts are not detailed but are simply outlined. There should be a back and forth play from the whole to the parts and from the parts back to the whole. Great attention to detail should come in the latter stages.

Fig. 1 utilizes the double triangle. Fig. 2 is a simple sectional outline. In fig. 3 semi-parallel lines are used (shaded area points out that parallel leg strips move toward outside of hips). Fig. 4 shows body in suit.

117

SUGGESTIONS FOR DRAWING MALE ATTIRE

1

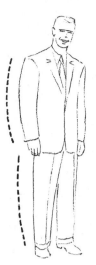

The lines of a man's garment are not ruler straight but are fashioned to conform with his body beneath. Without the influence of wear or body bend there is a slight concave in the fabric's cut.

2

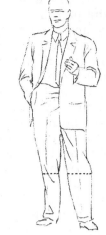

As the suit is worn and the various body parts move about, the material adapts itself to the person's mobile habits. Notice how the stance can cause the trouser legs to appear different in width.

3

Cross section of pant leg suspended shows crease front and back.

Cross section with limb in center. Old crease might cause cloth to swing free of contact altogether at this point.

Limb forced into crease or to side changes shape further (up and down drape tensions from belt or seat line have their influence).

4 The average length of a man's suit coat is even with the finger's second knuckles when the arm hangs at the side (see figure at upper left).

5

Age, quality and care of clothes have much to do with their appearance. Other factors seldom encountered may enter in, such as wind or water.

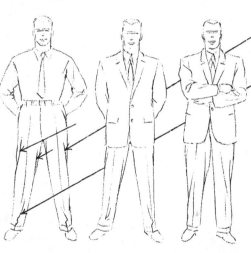

6

Observe how drape lines on side of pants SWING IN toward body center. Even line from crease break just above cuff swings in. See how hem of suit coat is even with crotch of pants. Hem is equidistant from outside shoulder point to cuff of trousers.

Left side of all coats always overlaps at front (same with pant front below belt buckle, but in drawing this is incidental).

7

Weight on right leg means that hip is held high. Pendent lines of folds in pants seem to hang from that right hip point. Notice slope of belt line.

Notice in semi-side view how upper pant leg portion nearest observer widens considerably through hip area at crotch level. Compare with width as seen at cuff line.

10

9 Refer to little triangle which often appears at seat below coat line.

8

When weight is shifted to one leg, and foot of other leg is set forward (as in figure above), then folds radiate from the high hip's pull. However, when weight is equally distributed on both legs, folds radiate from front.

When body weight is thrust forward on one leg, and foot of other leg is set back, then folds radiate from high point of supporting leg.

HOW TO DRAW SLEEVE FOLDS

Whenever the arm is moved from fig. 1's position, tension is set up somewhere on the circular seam where the sleeve attaches to the coat. Opposite this tension, crush will set in. Notice the slant of the fold angle as recorded in fig. 3 and (in the back) fig. 2. As the arm is raised the tension and crush become more severe. The shorter stretch from cuff to armpit seam pulls the cuff edge back as the arm ascends (follow figs. 1 through 8).

The above sketch illustrates crush and twist below the shoulder on the right arm and tension from the armpit seam on the far arm. Observe the telescoping of the crushed material on both arms.

Figs. A through D show the arm bent at the elbow. Fig. A is simple pen treatment. B has both the thick and thin. C shows a rather solid brush stroke. D employs a variety of pen and brush with some stutter lines and small line groups.

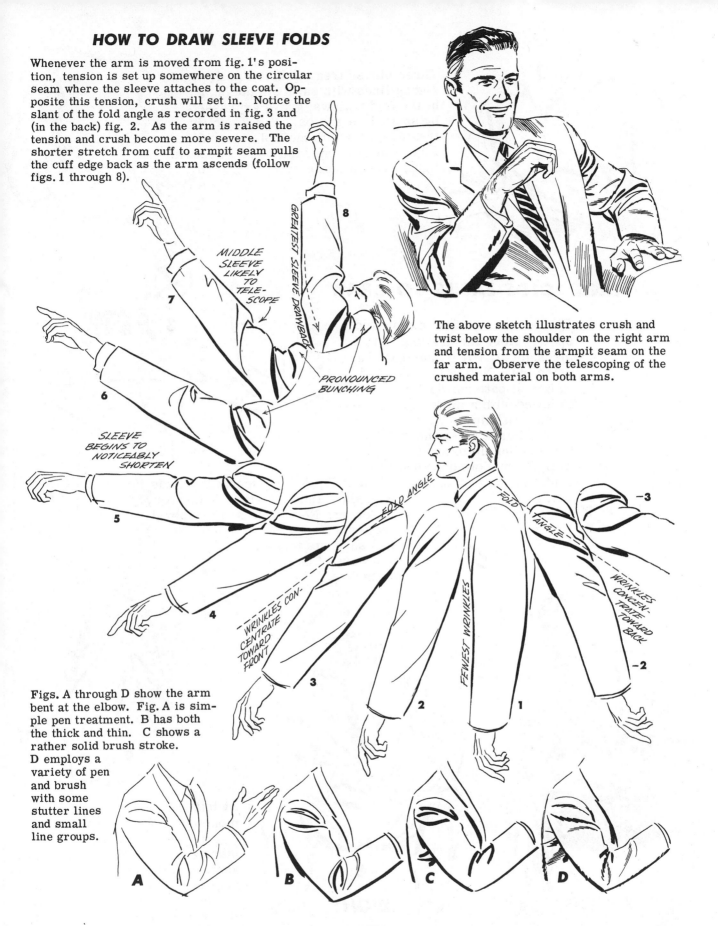

MIDDLE SLEEVE LIKELY TO TELESCOPE

GREATEST SLEEVE DRAWBACK

PRONOUNCED BUNCHING

SLEEVE BEGINS TO NOTICEABLY SHORTEN

FOLD ANGLE

FOLD ANGLE

WRINKLES CONCENTRATE TOWARD FRONT

FEWEST WRINKLES

WRINKLES CONCENTRATE TOWARD BACK

Three blouse treatments: Fig. 1, light zigzag lines with sawtooth edging on heavy fold hollows; grays expressed by small line groups. Fig. 2, softly treated edges with multiple sketch lines. Fig. 3, heavy, informal underlines with light, broken toplines.

MAKING FOLDS EASIER TO DRAW

Fig. 4 diagrams four major fold spots. Here the drawing is too mechanical, but it illustrates a principle. Notice the flattened elliptical pattern which may be followed with a more subtle, informal technique. In each case the top curve tucks into the bottom coming up to meet it.

In fig. 5 the dotted ellipse represents the "curve and tuck" fold of fig. 4. The secondary folds (black slash lines on either side) very often occur. Notice the same general directional sweep each takes (arrows). Fig. 6 suggests three other ways of handling the slashes.

CONCAVE CONVEX

7 WRONG

8 RIGHT

At left fig. 7 is overloaded with monotonous, belabored folds. Try a fresher approach with more breaks in the outline, more variety in the interior line thicknesses such as fig. 8. Fig. 9 offers another practice suggestion in line variation. Examine other artist's styles in developing your own. Draw experimentally!